B & W Photo-Lab
Printing Special Effects

In association with

Printing Special Effects

First North American Edition, 2000

Published by
Silver Pixel Press®
A Tiffen® Company
21 Jet View Drive
Rochester, NY 14624 USA
Fax: (716) 328-5078
www.silverpixelpress.com

ISBN 1-883403-82-0

© Rotovision SA 2000

Written by Julien Busselle

Book design by Saskia Gartzen

Printed in China

Printing Special Effects

Contents

Gallery

Ref. pg 98

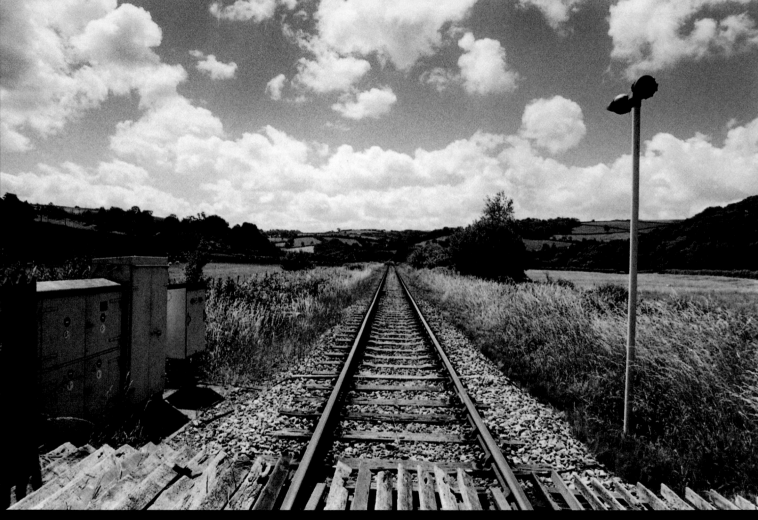

Ref. pg 48

Ref. pg 117

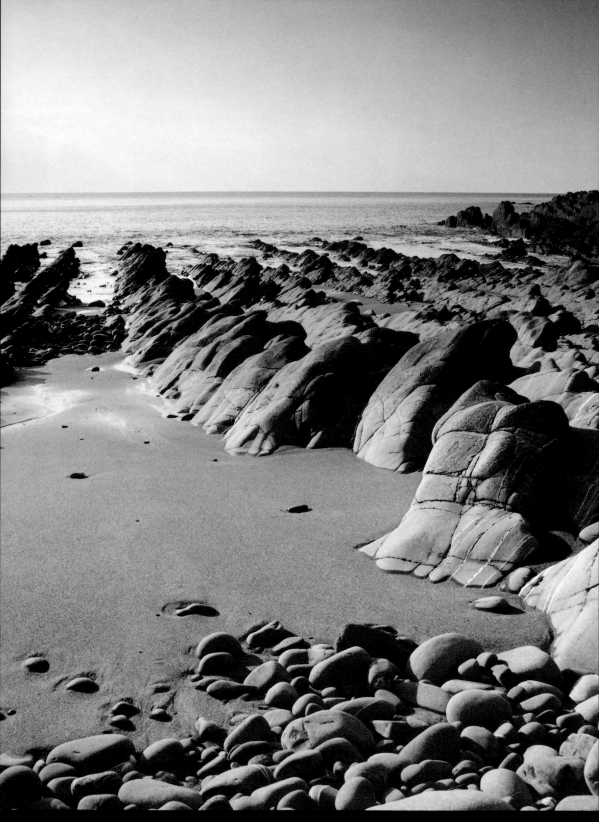

Ref. pg 42

Julien Busselle **Hartland**

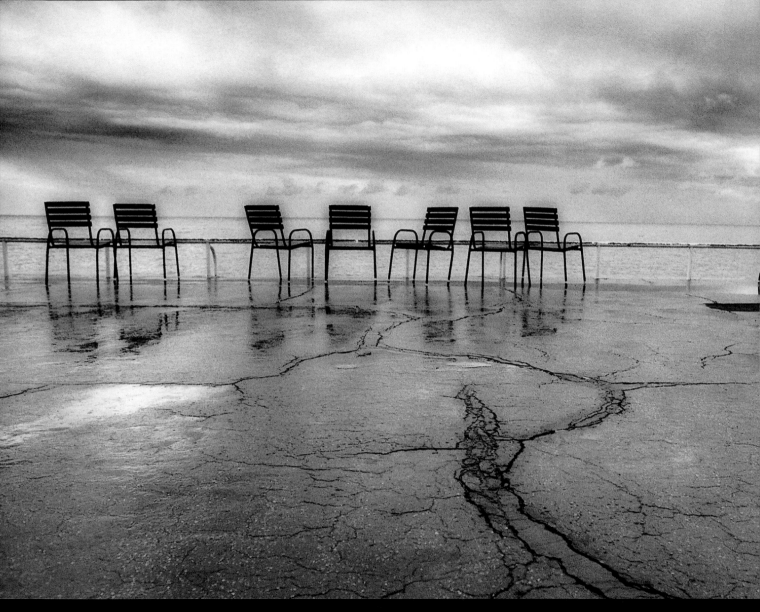

Ref. pg 104

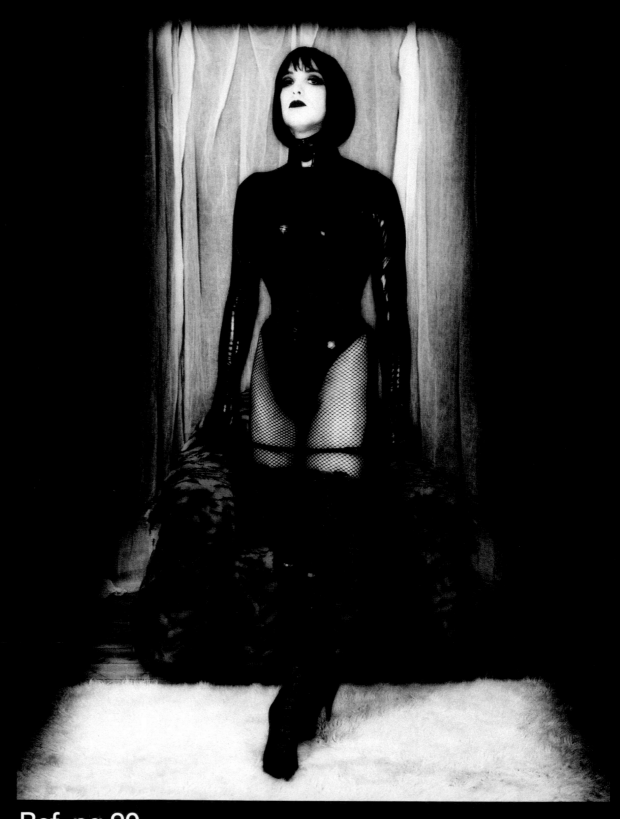

Ref. pg 90

Emma Delves Broughton **Katrina, 1997**

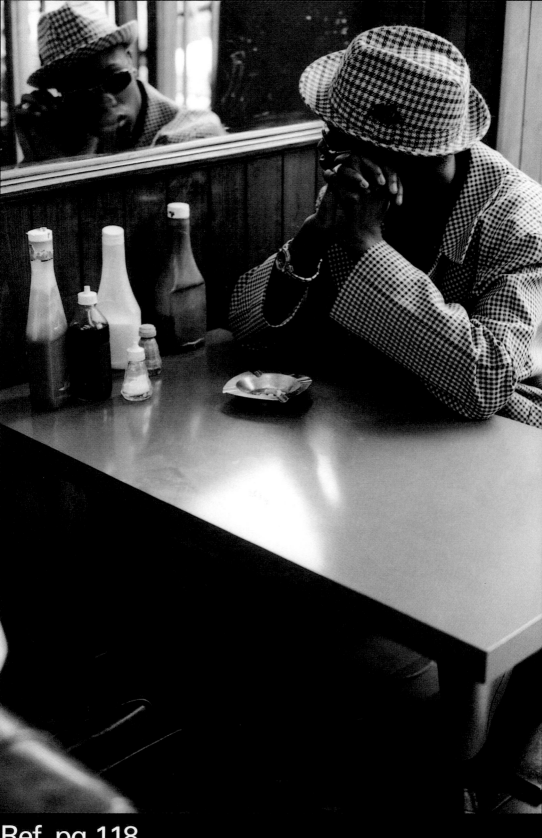

Ref. pg 118

Michael Miller **Time to reflect**

Films and Developers for Effect

Before you press the shutter of your camera to make an exposure, there is one very important creative choice that you can make – film selection. The photographer can also exploit the grain within the chosen emulsion, and either enhance or reduce it to create the effect that is desired.

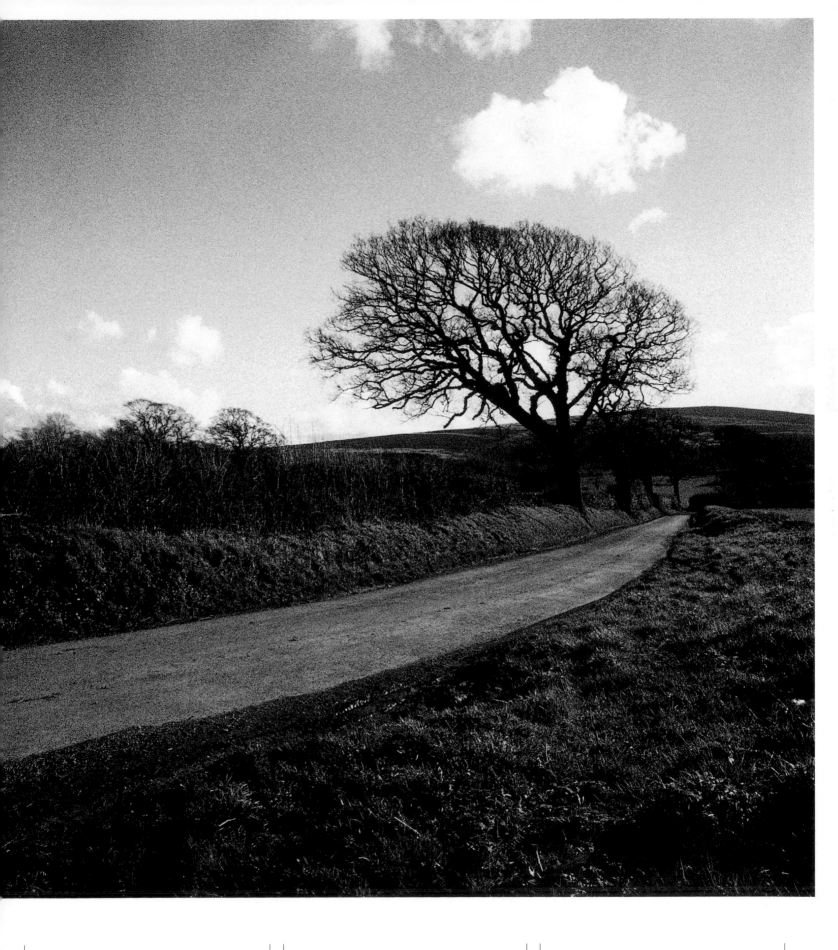

01. Speed and Grain

Film grain

The grain of a negative, which becomes visible once magnification or enlargement takes place, is created by the black silver grains that lay within the emulsion. As the film speed increases these grains become larger and more noticeable and the thickness of the emulsion that contains them has to increase. The result is that the resolution of the film goes down as the grain size goes up. Modern black-and-white films have finer grain than ever before; in particular, fast films now have grain comparable to that of slower films used in the past. Film manufacturers have made great strides to increase resolution and to eliminate intrusive grain. Kodak T-max and Ilford Delta are two of the 'new' breed of monochrome emulsions that offer these features. Developer, exposure and, of course, enlargement will all affect the film's grain structure as well as its speed. Since choosing a film marks the first stage of the development process, it is sensible to understand the effects that are possible with that film before it goes into the camera rather than later on when choices may become narrower.

Slow films and developing for effect

Slow films are generally recognised as having a speed of ISO 25–50. Slow indeed, but the grain structure is particularly fine and, as long as you are working with a subject for which the slow shutterspeeds that result will be appropriate, these are the films to go for in terms of 'clarity'. This clarity can be pushed further still by the developer itself. Slow films have not only a very fine grain structure but, due to the thin emulsion, a very high resolution. This leaves the photographer with two distinct paths to follow in order to enhance the characteristics of a film of this type: developing to enhance the sharpness of the negative or developing to achieve a very fine-grained negative.

Enhancing sharpness

For ultimate sharpness in a slow, fine-grained film an acutance developer is unbeatable. An acutance developer works by enhancing the contrast of edges and fine detail in the negative. Where dark tones meet light tones the developer exaggerates this, giving a dark outline to dark areas and a light one to light areas. By doing this an illusion of sharpness is created. This type of developer may also increase the speed of a film and its grain size.
Consequently, its perfect in combination with a slow, fine-grained film where absolute sharpness is required, but for keeping grain size to a minimum you have to look at a different option.

Print: Croyde Sand Dunes, North Devon, UK

This photograph was taken on a medium-format camera using a very slow film chosen for its resolution. This particular shot was pre-visualised and the use of an acutance developer was essential to the final concept since the sharpness was the top priority here. The slight increase in grain that resulted was easily compensated for by the combination of a fine-grained film and the larger format.

Technical Details
I used my 6 x 4.5cm SLR with an 80mm lens. Exposure was 1/8 second at f16. The photograph was taken on Agfa APX 25 (ISO 25) and developed in Agfa Rodinal, a high-acutance developer, to maximise the sharpness. Development time was 9 minutes at 20 degrees C.

Print Details
I gave this print an exposure of 32 seconds at f5.6 on Ilford Multigrade IV FB warm-tone paper. This was then developed in the matching developer for 2 minutes. I used a variable-contrast diffuser enlarger with a contrast setting of 4.

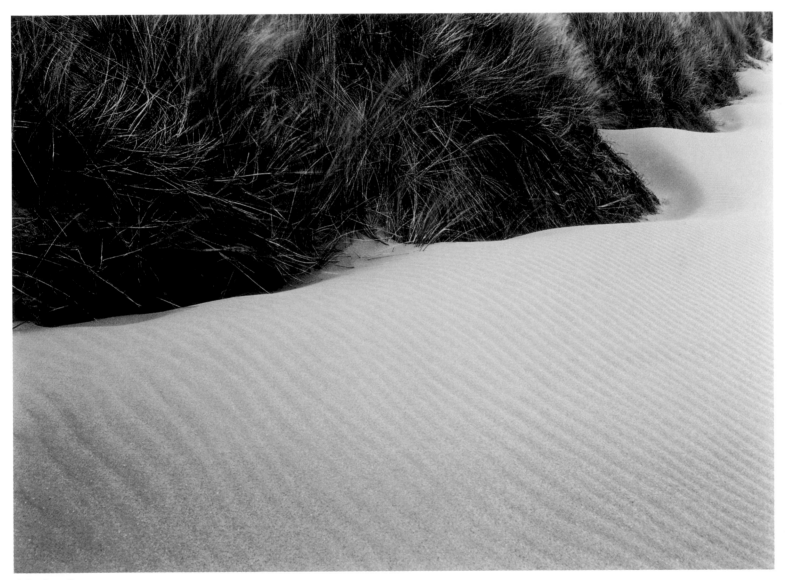

Julien Busselle

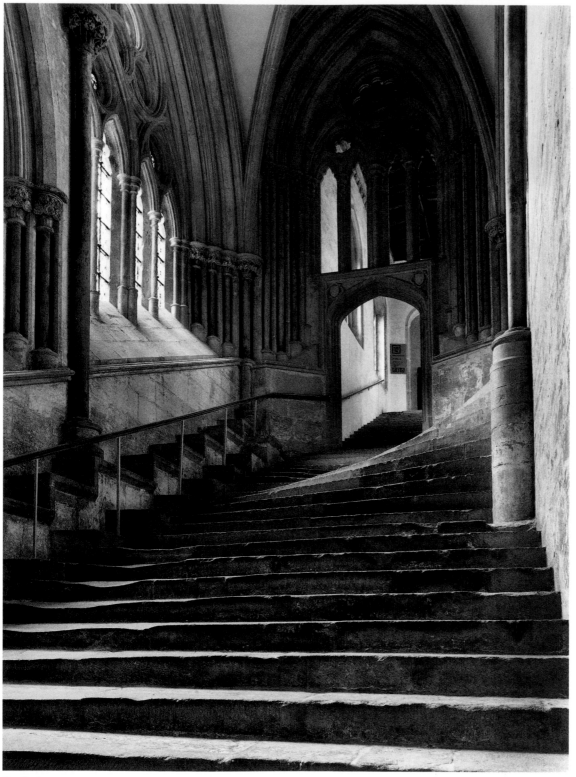

Ray Hadlow

Print: Stairs to the Chapter House, Wells Cathedral

This print by Ray Hadlow demonstrates careful film selection and development. Ray shot this interior using a tripod to guarantee stability so that the film speed and grain could be kept to a minimum. The level of contrast created by a dim interior and the relatively bright light from outside looked like it might cause the photographer some problems. By 'pulling' the speed of the film, however, Ray was able to reduce the development time and therefore smooth out the contrast levels; the interior became more even with more detail in the shadows and highlights. A further advantage of this technique is the smaller grain size, beneficial especially in Ray's finished exhibition print of 16 x 20 inches.

Technical Details
6 x 4.5cm SLR with a 55–110mm lens. Exposure was 1/8 second at f16. Ilford FP4 ISO 125 downrated to ISO 50. The film was processed in Ilford Ilfosol-S for 3 1/2 minutes at 1 to 9, 20 degrees C.

Print Details
Agfa Record Rapid fibre paper grade 3. The print was developed in Agfa Neutol for 2 minutes. Exposure time was 45 seconds, made on a condenser enlarger.

02. Film and Grain

Minimising grain

If your priority is to keep the grain of the film to an absolute minimum, particularly important if you're using a smaller format such as 35mm and want to produce large prints, you will need to use an ultra-fine grain developer. The grain structure of a film is reduced when using these developers, although this will be accompanied by a slight lowering of contrast and acutance. The result is less noticeable film grain at the cost of apparent sharpness, while a further disadvantage is that these developers can reduce the speed of the film. The developer is at its most effective when used with slower and more fine-grained films, and the quality you are able to achieve with this combination is outstanding.

Pulling film speed

By decreasing the film speed and reducing the development time it is possible to reduce the grain size within the emulsion and give an increase in overall quality. This is known as pulling the film speed. Pulling film speed will reduce the level of contrast within a scene, so it is particularly useful when tackling a high-contrast image on a slow film since these films have a tendency to produce a contrasty image anyway. Pulling the speed of a film too far, however, will make the image flat and reduce definition.

Tip: The use of a fine-grain developer offers good acutance and grain size, a compromise between the acutance developer and the ultra-fine grain developer. It is more of a standard developer than one that you might use to gain a particular effect in a film, but if you have different subjects on a roll of film and are unsure whether to develop for acutance or fine grain then this is a good middle road. The suitability of each developer will be determined by the end result you wish to achieve; by extending one characteristic of a film you may find you impair another. Careful selection is the only option if you wish to create a definite effect.

03. Film Speed and Grain

Fast films

The use of high-speed films is not limited to fast-moving subjects and low-light situations. The grain of a fast film can be extremely attractive and can result in a pleasing and eye-catching effect. A modern fast film of ISO 400 is likely to have very little apparent grain, so you're likely to be looking towards very fast films of ISO 1600 or more if you really want the grain to become a prominent feature of the picture. By pushing a fast film you can also increase grain size although this will raise the contrast level at the same time, which may not be suitable for some subjects. Another approach is to frame the image so that a small section can be enlarged for printing in the darkroom, allowing full advantage to be taken of the gritty grain structure of a fast film. Whilst ISO 400 is the bottom end of the range of fast films the top end sees films of ISO 6400 which, when combined with extended development, can give a film speed of up to ISO 25000! Perhaps the most famous 'grainy' film is Kodak's 2475 recording film. Although rated at ISO 1000 this film produces a lovely coarse grain pattern that is hard to achieve even in much faster films. It is also not too contrasty and is great for skin tones.

Speed-enhancing developers

These developers work by giving a small increase in film speed whilst retaining a relatively fine grain structure, and are therefore of little use when trying to increase grain in a film. To increase the size of the grain, films processed in these formulas need to be push processed.

Push processing

This technique involves uprating the speed of a film and extending development. It produces not only an increase in the film's speed but also gives a higher contrast image. The film's grain structure is increased, but excessive contrast can occur if the film is pushed beyond its limits or if the scene is already high in contrast. Extreme development results in empty shadows, and, as when pulling the speed of a film, the pleasing effect will be lost and only a poor image will occur if the process is taken too far. Most films come with a development guide that will suggest times for push processing. If you are without these guidelines then for each stop that you cut the exposure and up the film speed you should extend the development time by approximately 35%.

Tip: By using a clip test you can check the development and effect before committing the entire roll. Clip the first few frames off a roll of 35mm film and the last few off 120 roll film. By processing these you can then fine tune the development for the rest of the roll. It is always best to do this by taking additional shots of a scene that is representative of what is on the rest of the roll, so that adjustments you may make to the development can be more accurately considered.

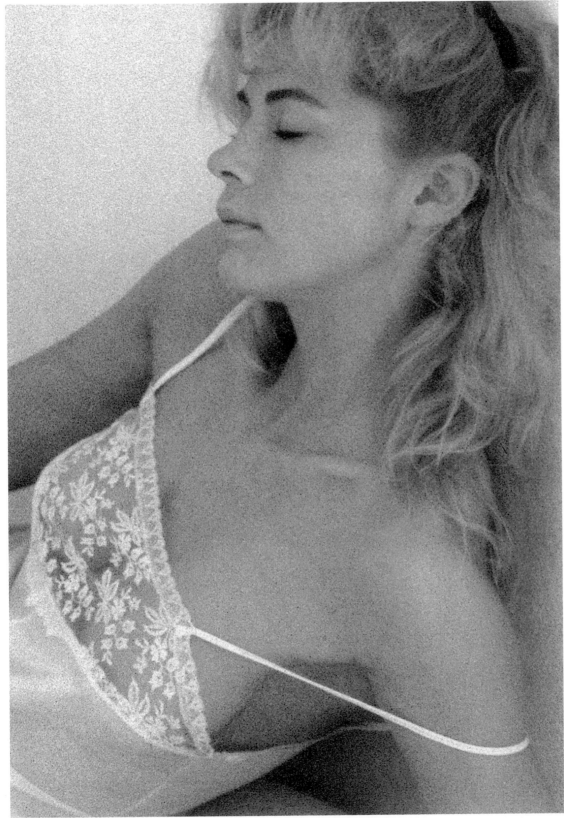

Michael Busselle

Print: Nude Study

This picture was taken using Kodak 2475 recording film, chosen for its very grainy effect. To emphasise the grain the lighting was kept relatively soft to create an airy feeling with plenty of light and mid tones, and this has allowed the grain to become prominent.

Technical Details
A 35mm SLR was used with a 105mm lens. Exposure was 1/125 second at f5.6. Kodak's 2475 recording film (ISO 1000) was processed in Ilford's Ilfosol-S for 9 1/2 minutes at a dilution of 1 to 9.

Print Details
The print, for a model's portfolio, was made on Ilford Multigrade RC paper with a filtration grade of 4. The print was processed in Ilford Multigrade Developer diluted 1 to 9 for 60 seconds. Exposure time was 30 seconds at f5.6. The enlarger was a diffuser type.

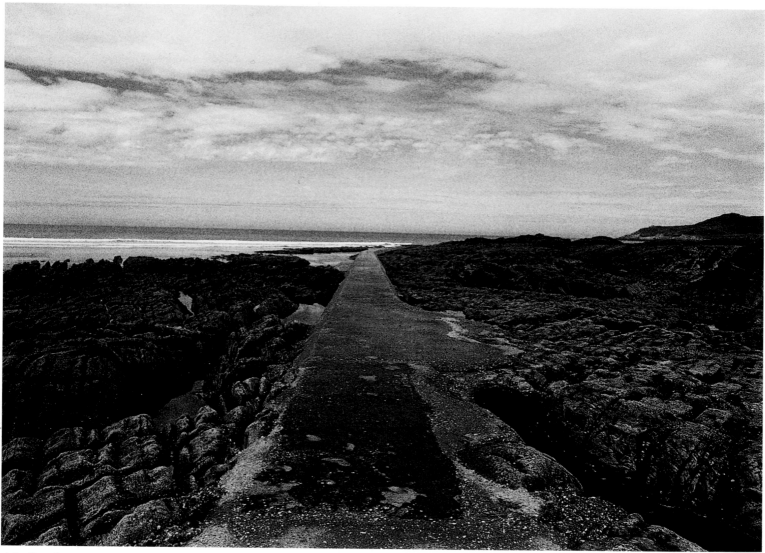

Julien Busselle

Print: Concrete Jetty, Morte Bay

The perspective created by this length of concrete disappearing into the sea was enhanced by using a very wide angle lens. I used the rocks on either side to act as a natural frame, keeping the landscape format rather than using an upright format and excluding them.

Technical Details
35mm SLR with a 24mm lens. I used an orange filter to increase the contrast slightly and gave an exposure of 1/125 second at f16 on Fuji Neopan ISO 1600 film. The film was used at its suggested rating and not pushed, because I wanted the grain effect to be noticeable but still subtle. The film was processed in Ilfosol-S for 5 minutes at a dilution of 1 to 9.

Print Details
I used Ilford Multigrade IV resin-coated paper for this print. The exposure time was 15 seconds at f5.6 with a contrast factor of 4 and it was made on a diffuser enlarger. The print was developed for 60 seconds in Ilford Multigrade developer.

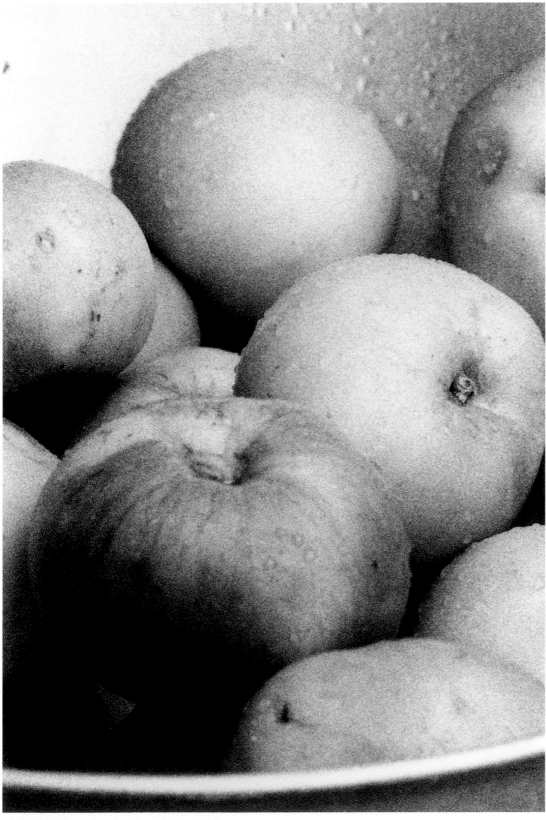

Julien Busselle

Print: Apples

This photograph was taken on a fast ISO 600 film and then push processed for a specific reason. The shot was intended for use in a recipe book and the brief was fairly strict – in this case a shot of some apples to illustrate the recipe for an apple pie. I was confronted with a selection of the worst apples I had ever seen – great for a pie but a real eyesore for a photograph. Unfortunately I was told that I had to produce a photograph of these particular apples and no others would do.

I used Fuji Neopan and framed the image in the centre of the viewfinder so that I could make a suitable enlargement to increase the grain size. My idea was to create a very grainy image that would disguise the condition of the apples. I made sure that the lighting was very soft so that the film, when pushed, would not become too contrasty.

Technical Details
I used a 35mm SLR with a 90mm macro lens. Exposure time was 1/8 second at f8. I used Fuji Neopan 1600 (ISO 1600) which I rated at ISO 3200, and developed the film in Kodak HC110 at dilution B for 11 minutes at 20 degrees C.

Print Details
Ilford Multigrade IV resin-coated paper with a contrast factor of 4 produced on a diffuser enlarger. The exposure time was 22 seconds at f5.6, developed for 60 seconds in Ilford Multigrade developer.

04. Infrared Film

Infrared film

This specialist film can give some very startling effects. It has the ability to create an almost dreamlike image but it is not the most straightforward film to use. The normal light that we see and record is in between the short ultraviolet and longer infrared wavelengths. Infrared wavelengths are invisible to us because they are below the red end of the visible spectrum. The most dramatic results with this film occur when the material is used in combination with a deep red filter such as a 25a or a visually opaque filter such as the Kodak wratten 87, 87c or 88a. Obviously the red filter is easier to use as it is still translucent enough to allow framing and an exposure reading to be taken while on the camera, whereas the wrattens will need to be removed and then put back in place to allow these processes to occur. A good deal of experimentation is needed when using this film as focusing and exposure are different to what you would expect if using a conventional black-and-white emulsion. There are a number of different types of infrared film available; the newest and most straightforward to use is Ilford's S8X 200, but Konica also make one, known as Infrared 750, while the most famous is Kodak's 2481 high-speed infrared, which offers by far the most extreme effect.

Loading and rating infrared film

All infrared film needs loading in subdued light and this is certainly true with both the Konica and the Ilford films, but the Kodak film is so light-sensitive that it needs to be loaded and unloaded in total darkness. Do not remove the cassette from the film canister unless you are certain of complete darkness. Infrared film can be fogged very easily and, in some cases, this fogging can occur by using the film in one of the many modern cameras that uses an infrared sensor to count the film's sprocket holes. You may also find a problem with older cameras that have a window that allows you to see the film cassette label. In the case of the latter, you can mask the window off to avoid trouble, but if your camera has an infrared sensor it cannot be used with Kodak 2481 infrared film.

The levels of infrared light vary dramatically and, as a result, ambient light meters cannot measure it accurately and the suggested film speed may need adjustment. With Kodak's infrared film and the deep red filter in place, try rating it at ISO 400 and your camera's meter should automatically take into account the light loss caused. Give exposures at the reading suggested and then at least one stop above and below this. The Konica film is very slow at about ISO 50, but take an exposure reading in the same way and make sure that you bracket the exposures again. The Ilford SFX film is more reliable at ISO 200 but it is always sensible to take precautions with the exposure.

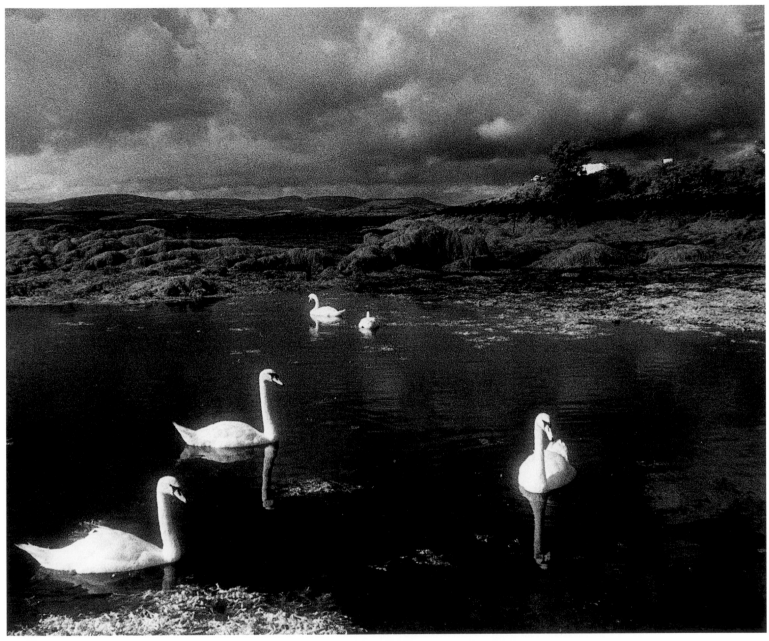

Sean Kennedy

Print: Swans

Sean's picture was taken in West Cork, Ireland, where he was camping whilst on a photographic trip. The swans appeared in the evening, coming into the inlet by the campsite to take advantage of any spare food. Sean used Kodak infrared film to make the picture appear different and slightly surreal. He waited for the swans to gather in the formation he wanted and took care to include some of the landscape.

Technical Details
35mm SLR camera fitted with 28mm lens and a red filter. Sean used Kodak's high-speed infrared film rated at ISO 400, developed in Kodak D-76 at a dilution of 1 to 1 for 15 minutes.

Print Details
Ilford Multigrade IV RC paper in a gloss finish. This was processed in Multigrade developer for 60 seconds, diluted 1 to 9. Sean used a condenser enlarger and gave an overall exposure of 15 seconds at f5.6 using a contrast filter of grade 3.

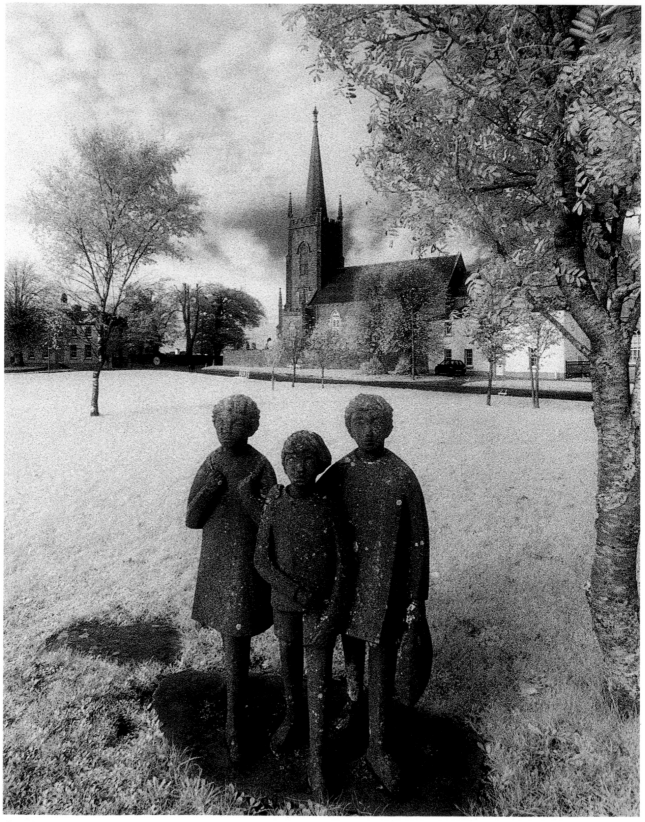

Sean Kennedy

Print: The Village Green

This shot was taken by Sean at noon. The level of infrared radiation at this time of day is high, helping to accentuate the effect of the film. Sean was travelling at the time and stopped at the village called Tyrellspass. The guide he had with him described the place as being deliciously pretty and Sean immediately set to work looking for a shot. The image is of a new feature on the village green, and the picture was composed carefully to include the church and plenty of snow-like foliage in the background.

Technical details
35mm camera with a 19mm lens. Sean fitted a deep red filter and rated the Kodak 2481 infrared film at ISO 400. Exposure was 1/60 second at f16. The film was processed in Kodak D-76 for 15 minutes at a dilution of 1 to 1.

Print details
This print was made on a condenser enlarger with Ilford Multigrade IV gloss paper. Sean used a grade 3 contrast setting and processed the print in Multigrade developer for 60 seconds at a 1 to 9 dilution. Exposure time was 18 seconds at f 5.6.

Focusing and developing

Infrared radiation focuses on a different point to visible light, so some adjustments are needed to achieve a sharp result. If you are using an apochromatic lens then you are unlikely to encounter any problems as these lenses are corrected so that all colours of the spectrum focus at the same point. If you have a conventional lens it is likely to have an infrared focusing mark on the barrel – usually a small red dot to the left of the main focusing index. This is the point which you will need to re-focus on. If your lens doesn't have this mark, then re-focus slightly to the left of the main focusing index. Using a small aperture will also help to ensure a sharp result. It is often suggested that when developing infrared you should use a stainless-steel tank, since the plastic versions can allow infrared radiation to penetrate and to fog the film. If you only have a plastic tank then don't be put off, as I know many enthusiasts, myself amongst them, who have used them with infrared films and experienced no problems. One further point to take into consideration when developing infrared film is that it is made of a much thinner base than conventional panchromatic film and needs considerable care when handling. You'll also need to be extra careful when printing, because once processed and dry it will have a tendency to curl right over itself, and will be difficult to straighten out. Below are some of the preferred developers and times for use with Kodak's 2481 infrared film.

Suggested times and developers for Kodak 2481 infrared film

Although these times are a good starting point, some degree of adjustment is usually needed to allow for personal taste.

Kodak D-76 stock	11 minutes
Kodak Hc110 dil. B	6 minutes
Ilford ID 11 stock	12 minutes

Tip: Infrared film can create a number of problems at the printing stage largely because of the high contrast caused by the reflected infrared radiation from foliage. Prints made from infrared negatives may require a fair degree of dodging and burning in to produce a balanced result. Although a result can be achieved without the need for any special papers or developers, toning the prints can be very effective indeed. The use of a sepia toner creates an especially pleasing image, blending the special qualities of the film, such as the snow-white foliage, with a touch of nostalgia contributed by the sepia.

Section 2

Toning Prints

By toning your prints it is possible to change or to accentuate the mood, to add colour and sometimes to increase the life of the print. Using multiple or split toning effects can create very personal images, whose appearance is as subtle or extreme as you choose.

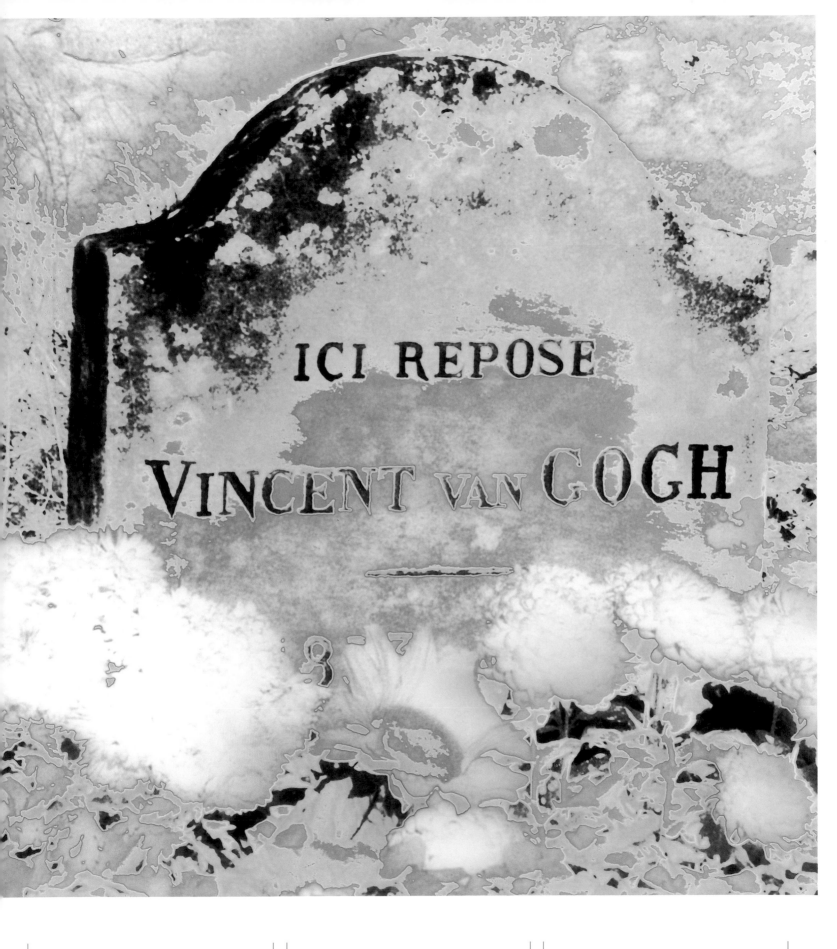

01. Choosing a Toner

Toning is not an exact science. It can be unpredictable at times and the best thing anyone new to toning can do is to keep a record of everything carried out. Don't expect to reproduce a particular effect exactly. Treat the record like a recipe: adapt it, add to it even, but don't expect the same result every time. Above all enjoy the toning process – it can transform your pictures, while freeing you from the confines of working in the dark.

Blue toners
This is a straightforward one-bath toner which produces a strong blue image. The toner is based on a Prussian blue dye, and will not extend the expected life of your print. By placing the washed and blue-toned print in selenium toner, the blue will begin to split tone, gradually becoming greyer while the blacks become more dense. This produces a nice effect, which is more subtle than the straight blue. Straight blue-toned prints can be brought back to their original untoned state by returning the print to the developer; a brief spell in this will also 'knock back' the blue. To create an even bluer image tone, redevelop, wash and tone again. Blue toners vary but usually an increase in both contrast and density occurs in the toner – avoid contrasty and/or dark prints for this reason.

Brown toners
The simplest of the brown toners is Agfa Viradon. This does not require a bleach and is a single bath toner that produces a chocolate-coloured brown. It is more restrained than sepia, but it does produce a lovely rich effect, particularly with warm-tone papers such as Ilford Multigrade FB warm and Forte Polywarm-tone. It produces an archivally sound image in around 60–90 seconds at a dilution of 1 to 50.

Sepia
This is a two-bath toner that consists of a bleach bath followed by the sepia bath. It produces an image that is both archivally sound and pleasing for its hint of nostalgia. The degree of the toning can be influenced in each of the two baths. Firstly, the bleach bath can be used to completely bleach the print so that the image formed in the sepia bath will be fully toned. If you wish to leave the shadow tones unaffected by the sepia then you can partially bleach the print so that only highlights are affected. The second way to influence the print is by the dilution of the sepia bath. A more dilute bath will produce a yellow-brown image whilst a stronger dilution will produce a darker, richer brown. Sepia works best and quickest with fibre papers. Although it will work with resin-coated papers, the wait for the image to bleach can be a long one. Again, this toner is suitable for producing a print to archival standards.

Copper or red toners
These are generally supplied as a liquid concentrate, and both are very controllable toners. A range of colours can be expected, varying from a warm, almost selenium effect to a heavier copper-red colour. They tend to have a lightening effect on the print (the opposite of the blue toners) but by applying the same procedure as the blue toner – tone, develop, tone – the colour becomes more pronounced each time. In common with other toners it pays not to rush the time the print is in the bath; a long spell will produce a stronger hue. Copper toner, like the blue, does not produce an archivally sound print.

Green toners
The effect of green toner, like others, is dependant on

paper type and, as a consequence, testing with various papers is always advisable. These toners use a bleach bath followed by the toner bath. The toner itself can give anything from a yellow through to a pastel green or a strong dark green depending on the dilution that you use. The better results seem to come from the fibre-based chlorobromide papers such as Agfa's Record Rapid.

Selenium

This toner is perhaps more commonly used to help achieve an archival print when used at high dilutions of 1 to 20 up to 1 to 39. At this dilution a subtle change can take place where the print becomes 'intensified' – the blacks become richer and the contrast is slightly raised. This is a lovely subtle effect that could be used for all prints. At dilutions of 1 to 10 or even 1 to 5 the effect of the toner becomes more noticeable, giving a hint of gentle cool purple to a bromide print or a warmer blue-brown on a chlorobromide print. The effect does vary wildly and tests are recommended. And remember, the effect is quite subtle so be patient and persevere. Selenium also splits tones extremely well. Unfortunately, this toner is toxic so please take care to use it in well-ventilated situations and avoid all skin contact.

Gold

A good toner for archival purposes, if expensive. It is used undiluted and gives a cool blue hint to a print; nice but perhaps a disappointment if you were thinking it would produce a gold-toned print. The toner deposits gold metal on to the silver of an image and needs help to produce a gold effect. If this is what you want to achieve, first sepia tone a print, then gold tone. Results will vary from a pinkish colour to a near gold.

Colorvir

This is a kit that comprises everything you need to produce toned prints and some special effects. The instruction booklet included in the kit recommends that you only use resin-coated papers with the process, although I do know of people who have used fibre-based papers without any reported problems. The 'tones' are really a dye, and I would say that for this reason, if you want to produce prints of archival quality, it is best to use a toner like sepia, gold or selenium. The Colorvir kit does have one very special effect that is worthy of a mention and indeed I think that it is worth buying the kit for this alone; this is solarisation. The solarisation bath is very effective and controllable, although it can only produce its effect in combination with a tone. The print can be 'pulled' from the bath at any stage, giving anything from a subtle effect to an extreme solarised look.

Toning tips

1 Always thoroughly develop, fix (with a fresh solution) and carefully wash any prints that are to be toned – staining is far more likely to occur in a print that has been processed casually.

2 It is best to work alongside an untoned version of the print so that you have a visual reference and can judge the more subtle changes that take place.

3 Because toning can be done with the light on – or in daylight – it pays to take advantage of this and always work in good light.

4 Always keep prints that are a little too light or dark – they are not only good for testing a toner, but can be more effective than a 'perfect' print when used in toners that affect the density.

5 Use plastic/rubber tongs rather than metal as the latter can react with some toners. Also use rubber gloves rather than bare hands as this will prevent finger marks and give protection if working with a toxic toner, such as selenium.

6 Fibre-based papers tend to give the best results but resin-coated papers should not be ignored – they are ideal for experimentation.

7 Try a variety of papers in the same toner – all papers and toners respond differently so don't assume that because a paper has responded well in one toner it will work in another. Experimentation is the key to understanding your market.

8 Keep a record of your results. Although this doesn't mean that you can expect to repeat a toned print it will at least give you a valuable reference.

9 Never be afraid to experiment. Try different dilutions and temperatures and use more than one toner on a print. For example, sepia followed by gold can give wonderful results.

10 As repeating a toned image can be difficult or sometimes even impossible, make large-format transparencies of treasured toned prints. These will be acceptable for reproduction and are better sent out than a valuable original.

Split toning

This technique is applicable to a single toner or multiple toning. In essence it means that if toning is stopped before completion, there is enough silver left in the original print to ensure that some areas are unaffected by the tone. In the case of a single toning, such as selenium, if the print is 'pulled' before the image has become fully toned, then the shadows will exhibit the selenium whilst the highlights will appear unaffected. When using more than one toner, such as sepia and blue, try a brief spell in the bleach bath then the sepia toning, followed by blue toning. This will produce a print with sepia highlights, blue shadows and a hint of green in the mid tones. As a rule the first toner will affect the highlights and the last will affect the shadow areas. Reduce the time in the first toner by 25–30% and leave the print in subsequent toners until you are happy with the result. Please remember that this is a brief and general description – do your own tests to determine how the toners will react.

Toning essentials: a processing dish or dishes, plastic tongs, good light and ventilation. An untoned print placed next to the print being toned is invaluable as a visual reference – some changes are attractive but subtle, and may therefore be missed without the reference print.

03. Toning Effects

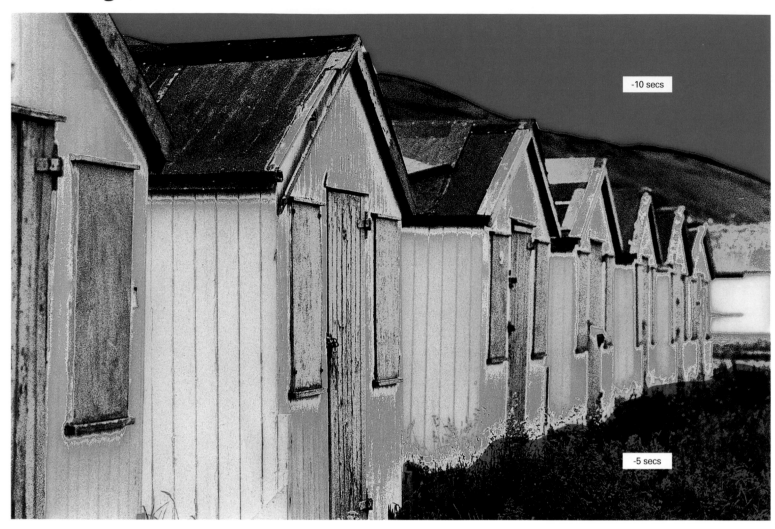

-10 secs

-5 secs

Print: Beach huts, Westward Ho!

I used my 105mm lens to compress the perspective in this picture, choosing to focus on the second hut and let the others 'fall away'. By compressing the perspective I not only created a striking effect, but excluded unwanted detail that included two elderly ladies who looked positively bewildered as to my attempts at excluding them from the picture!

Technical details
I used my 35mm SLR camera with a 105mm lens. Exposure was 1/60 second at f5.6. I also used an orange filter to boost contrast slightly and to darken the sky – although in the final print I was to omit the sky altogether. I developed the film, Ilford's HP5 ISO 400, in Ilford Ilfosol-S for 7 minutes at a 1 to 9 dilution.

Print details
The print was made on Ilford Multigrade IV paper, processed in Multigrade developer at 1 to 9 for 60 seconds. The contrast filter was set at 4 on my diffuser enlarger and I gave an overall exposure of 20 seconds at f5.6. I shaded the grass at the front of the huts for 5 seconds and chose to eliminate all detail in the sky by shading it for 10 seconds – this was done because I found it to be too intrusive.

Effect details
The print was washed, dried and then rewetted. I had taken this shot to show the effect of the solarisation bath which is part of an extensive toning kit produced by Colorvir. This method of solarisation is not only very effective but also simple to use, and fun! The process consists of two baths followed by a 'wash' in salt water before the final wash. The chemicals are heavily diluted for use, and consequently last a long time. For exact details and dilutions it is best to try the kit for yourself. I doubt you will be disappointed.

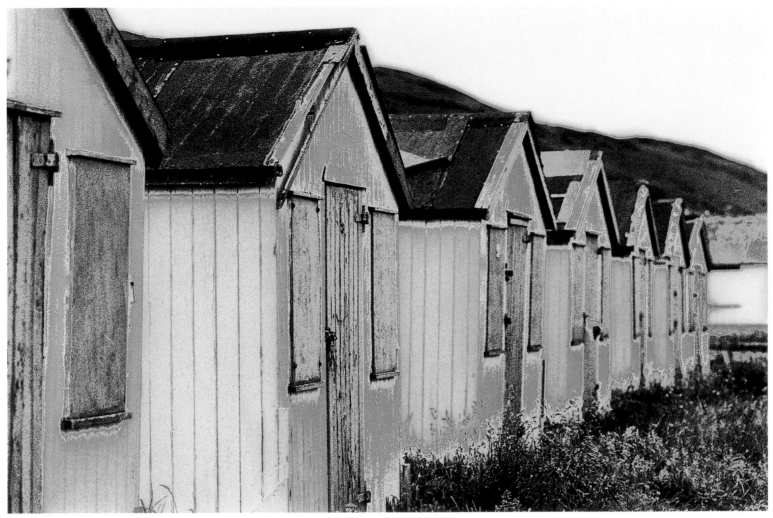

Julien Busselle

Print without effect

Print without effect

-15 secs

Julien Busselle

Print: Saunton Beach

This scene was taken from an elevated position, and the surfers walking back from the breakers were deliberately kept very small in the frame to add to the empty landscape. I used a fast film as I wanted to create a dreamlike image, and I felt that a good deal of grain would help me to achieve this. I had already planned at this stage to tone the picture, although as things worked out the final print didn't exactly follow my plans!

Technical details
This shot was taken on my 35mm SLR camera with a 105mm lens. Exposure was 1/125 second at f16. The film, Fuji Neopan ISO 1600, was developed in Ilford Ilfosol-S for 6 1/2 minutes at a 1 to 9 dilution.

Print details
The initial print was made on Ilford Multigrade IV paper and developed in the matching developer at 1 to 9 for 60 seconds. I gave an overall exposure of 55 seconds at f5.6 and during this I shaded the darker section of land only for 15 seconds, just enough to give a variation in tone. I set my contrast filter on the diffusion enlarger to give a contrast factor of 4.

Effect details
I used a diffusion filter to soften the image and to add to the dreamlike effect that I wanted to achieve. The filter I used was a Zeiss Softer III and was used under the enlarging lens. I had planned to sepia tone the image, but I had made three prints and decided to 'sacrifice' one of them in the blue and yellow solarisation bath that I had mixed up for the picture of the beach huts on the previous page. The print was rewetted and placed in the first bath until I was happy with the effect: this process took approximately 2 minutes. I then transferred the print to the second bath and waited for the solarisation effect to occur. The final, subtle result I wanted was achieved after 3–3 1/2 minutes and I then pulled the print from the bath and washed it. The effect of the blue on the wet sand worked far better than I had anticipated and the overall yellow tone gave the print exactly the feel that I was looking for. Although the final picture didn't turn out exactly as I had planned, I was very happy with the result.

Print: Lobster Pots

This was taken on a stroll around a local harbour. On this occasion I had not expected to take any pictures as my mind was too preoccupied with ice cream. I did, however, find this arrangement of pots too seductive to ignore, and took the picture with the 35mm camera that I carry with me on most occasions.

Technical Details
35mm SLR with a 24mm lens. Exposure was 1/60 second at f16. The film was Ilford's FP4+ developed in Ilfosol-S for 5 minutes.

Print Details
I made this print on Ilford Multigrade IV resin-coated paper, giving an exposure of 23 seconds at f5.6 with a contrast factor of 4. The left-hand side needed shading by about 6 seconds during the main exposure to prevent this area from becoming too dark. I developed the print in Multigrade developer for 2 minutes at a dilution of 1 to 9. The enlarger was a diffuser type.

Effect Details
I felt that this image needed a simple blue tone. This was the colour that was dominant in the original scene, as much of the rope used in the pots was made of blue nylon. The toner I used was produced by Tetenal.

Print without effect

-6 secs

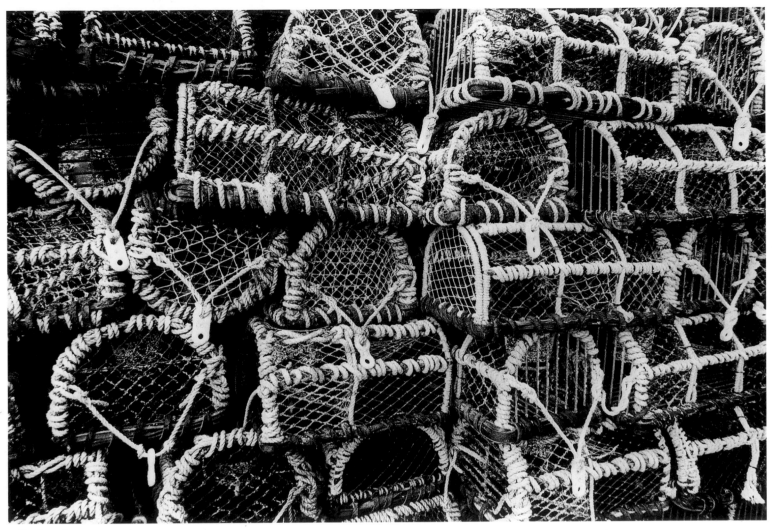

Julien Busselle

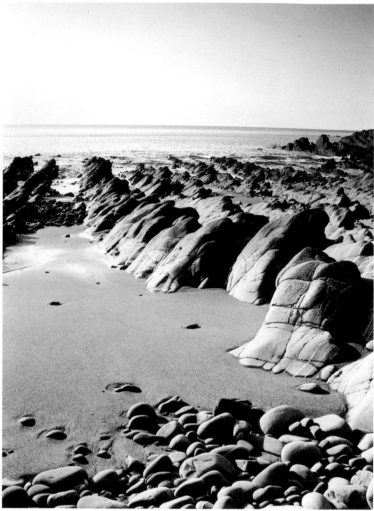

Print without effect

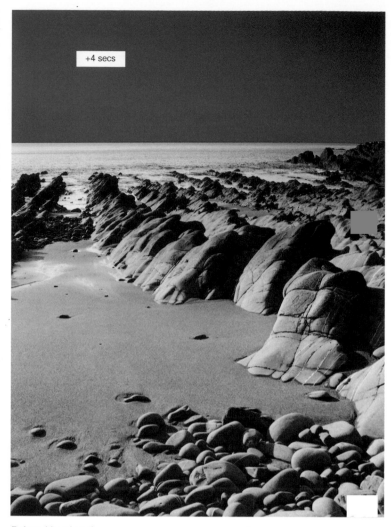

+4 secs

Print: Hartland

This shot was taken using the wonderful quality of light that late afternoon brings. I used a polarising filter to keep reflections to a minimum and to enable me to add some density to the sky. The smooth tones on the rocks and in the sand only lasted for a few minutes and, as the light began to change, the effect was lost.

Technical Details
6 x 4.5cm SLR with a 55–110mm lens. Exposure was 1/15 second at f16. The film was Ilford's XP2, developed in C-41 chemistry.

Print Details
I used Ilford Multigrade IV FB warm-tone paper with an exposure of 24 seconds at f5.6 and set my diffuser enlarger with a contrast factor of 4. I gave a hint of shading in the sky, only allowing an additional 4 seconds. I resisted the temptation to 'even up' the sky – the subtle gradation on the top-right was natural and I wanted to keep it that way. Then I developed the print in Multigrade developer for 2 minutes at a dilution of 1 to 9.

Effect Details
The final print was washed and placed in Agfa's Viradon toner – the lovely rich brown that this toner produces seems to work particularly well with the Ilford Multigrade IV FB warm-tone paper. The print was removed from the toner when I was satisfied with the effect, after about 3 minutes.

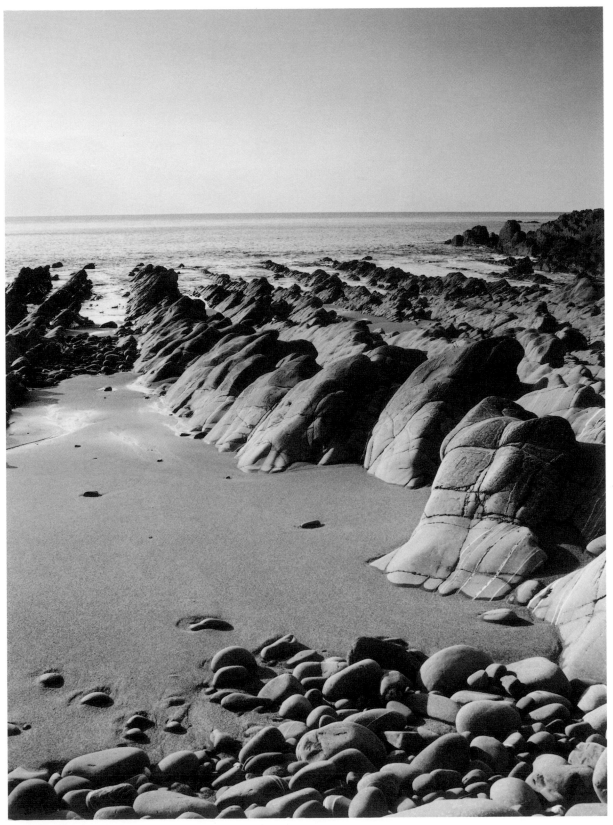

Julien Busselle

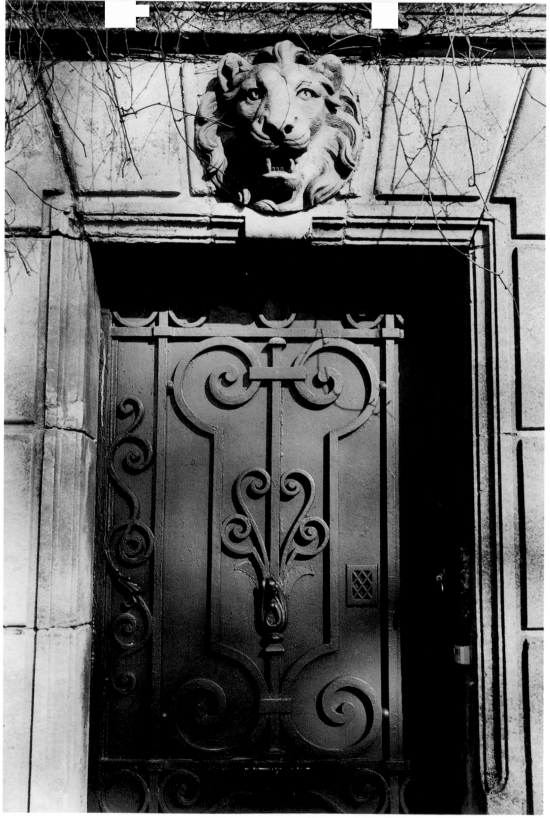

Print without effect

Print: French Doorway

This was taken shortly after I had photographed Vincent Van Gogh's grave – the doorway was just around the corner from the churchyard and looked splendid in the soft mid-morning light. The lion's head seemed particularly haunting, and I found this shot more atmospheric than the one that featured the headstone itself.

Technical Details
35mm SLR with a 28–70mm lens. Exposure was 1/30 second at f8. I used Ilford's XP2 film for its speed and lack of grain. The ISO 400 film was developed in standard C-41 chemistry.

Print Details
The print was made on Ilford Multigrade IV resin-coated paper and developed in the matching developer for 60 seconds. The exposure was 33 seconds at f5.6 with a contrast factor of 4. The enlarger was a diffuser type. No shading was used on this print but I have included the 'before' print to give a comparison with the final print.

Effect Details
This print was sepia toned, allowing the image to fade in the bleach as far as it would go. I then placed the print in the sepia bath for 2 minutes to give a rich brown effect. Next I added the print to a tray of gold toner to create the peachy tones in the highlights. Sepia followed by gold often gives a lovely effect – sometimes the result is very strong, creating near-gold highlights whilst retaining deep brown shadows.

Julien Busselle

Print: Track to Lee

I came across this shot on my way home from a shopping trip. It is a scene that I pass almost daily and yet I had never considered capturing it before. The puddles of water in the track and the deep shadows caught my attention and I had to stop the car. Luckily I had my 35mm camera with me at the time, and this was loaded with film ready for a spontaneous shot.

Technical Details
35mm SLR with a 28–70mm lens. Exposure was 1/60 second at f16. The film was Ilford's FP4+ developed in Ilfosol-S for 5 minutes.

Print Details
The print was made on Ilford Multigrade IV WA fibre paper, which was given an exposure of 20 seconds at f5.6 with a contrast factor of 4. I gave the sky an additional 8 seconds to emphasise the impression of the dispersing rain clouds – the sky without the additional exposure was, I felt, too weak. I developed the print in Multigrade developer for 2 minutes at a dilution of 1 to 9.

Effect Details
I decided to sepia-tone this print. I had a strong image in my head of the result I wanted and for this reason I chose to keep the sepia effect more yellow than brown. The print had been thoroughly washed and then placed in the bleach bath where it stayed until it became only partially bleached – I wanted some blacks to remain and did not want the image to become fully toned. The print was then washed and placed in the sepia bath for 2 minutes.

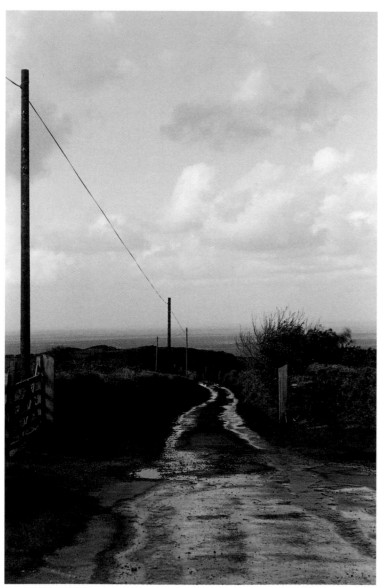

Print without effect

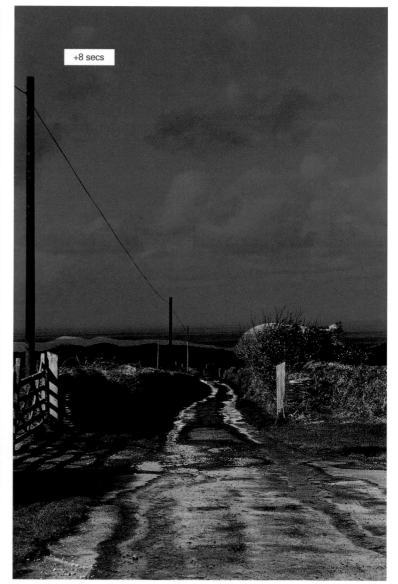

+8 secs

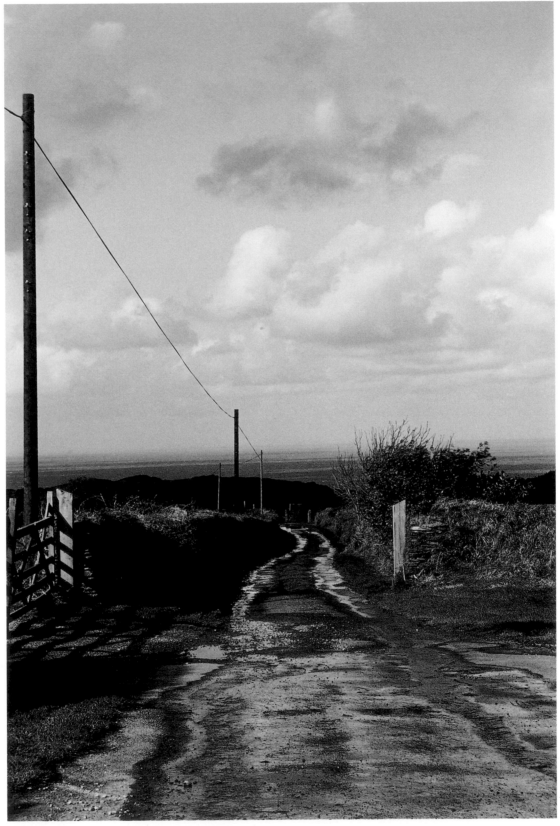

Julien Busselle

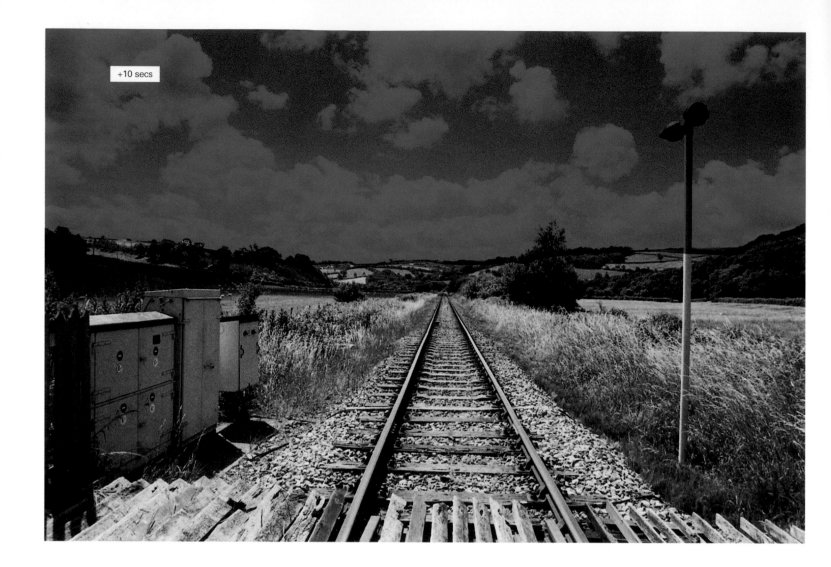

+10 secs

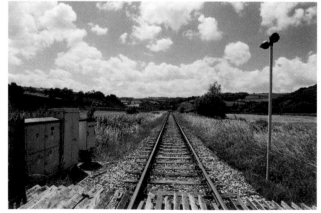

Print without effect

Print: Railway Crossing

I stopped my car well away from the track and walked back to take this picture – just in case! I am constantly drawn to tracks of any type and this proved irresistible. I managed to grab a couple of shots on my 35mm camera before the clouds blew over.

Technical Details
35mm SLR with a 24mm lens. Exposure was 1/60 second at f11. This was taken on Ilford HP5 (ISO 400) and was developed in Ilfosol-S for 7 minutes at a dilution of 1 to 9. I also used a red filter on this shot to darken down the sky and to add drama to the clouds.

Print Details
I used Ilford Multigrade IV resin-coated paper and Multigrade developer, developing the print for 60 seconds. The exposure was 20 seconds at f5.6 with a contrast factor of 3.5. I gave a further 10 seconds exposure to the sky only, to accentuate the clouds further. The print was made on my diffuser enlarger.

Effect Details
The print was thoroughly washed and then toned in a simple blue toner until a strong colour change took place. Then the print was washed and placed in a selenium toner at a dilution of 1 to 20. I used constant agitation until the blue began to recede and the selenium started to increase the shadow density.

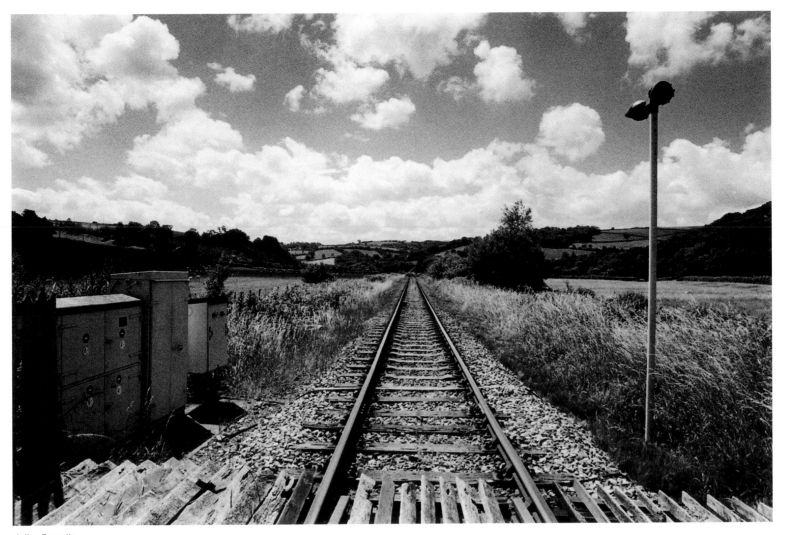

Julien Busselle

Print: Holly Leaf

The original, untoned print was used as a Christmas card. I placed the holly leaf on some glass and backlit it, adding highlights with a small torch to bring out texture. A while after I had done the shot I found some prints that had been left over and decided to have a go at toning them – just for fun.

Technical Details
6 x 4.5cm SLR with an 80mm macro lens. Exposure was 1/60 second at f16. The film stock was Agfa APX ISO 100, developed in Agfa Rodinal for 5 minutes at a dilution of 1 to 25.

Print Details
This was printed on Ilford Multigrade IV fibre-based paper and put through Multigrade developer for 60 seconds. The exposure was 35 seconds at f5.6 with a contrast factor of 4. The print was not shaded in any way, so I have included the original, untoned print for comparison.

Effect Details
The print was rewetted for 2 minutes after which I placed it in a bleach bath until only 35% of the image remained. Then I placed the bleached print in a green toner mixed up to give a strong green hue. The green toner reduced the contrast and made the image lighter, so to bring back some density and contrast I selenium-toned the print at a dilution of 1 to 15 for about 3 minutes.

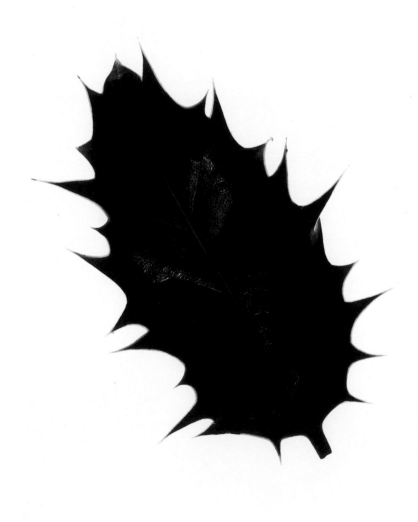

Print without effect

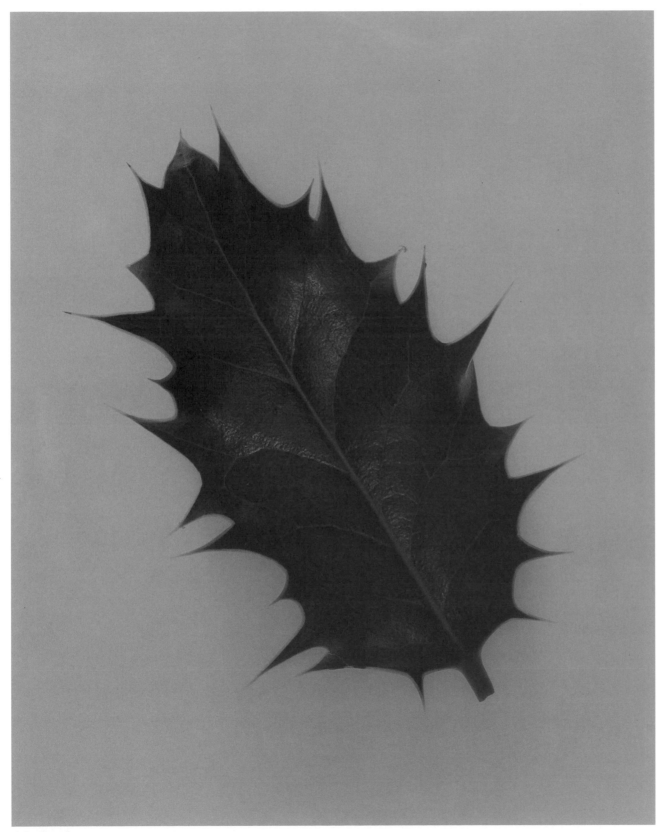

Julien Busselle

Filters and Screens

The use of a texture screen or a diffuser in the darkroom is an easy way to add to the list of darkroom effects that can be called upon. All kinds of everyday materials can be put to use to create amazing and bizarre images. Experimentation is the key, and extra drama can be added by toning your results.

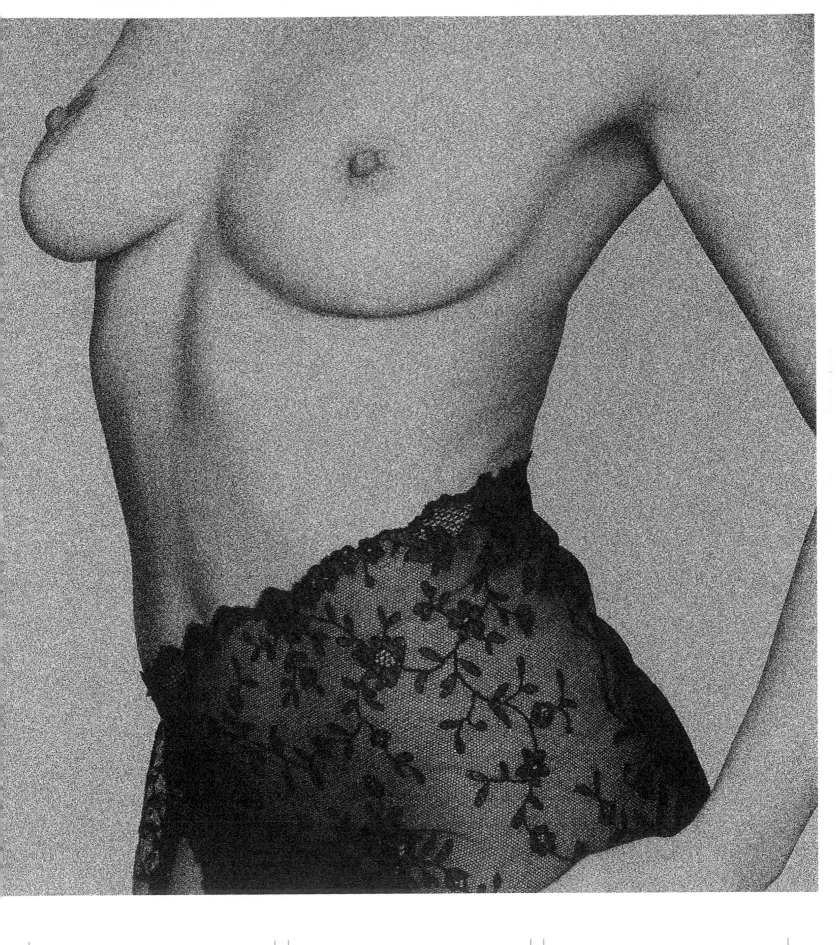

01. Filters and Screens

Diffusing the light source

There are many different ways of creating a diffused effect in the darkroom, ranging from the use of a special filter over the enlarger lens to the more improvised methods of diffusing the lens by covering it with a piece of suitable material. Placing the chosen diffuser over the lens will create an effect ranging from a slightly softer than normal print to an almost Impressionist image, depending on what you use. Most reliable is a simple diffusion filter – these are available in different strengths, so you can cover a number of options. As an alternative it is possible to use a plain glass or resin filter and then to add a diffusion effect by smearing it with a light coating of petroleum jelly – this is less controllable, but creates more of a surprise result. Another technique is to cover the lens with a piece of material – a section from a pair of tights is well known and really quite effective – although you might have to experiment with different brands and thicknesses to get the desired level of diffusion. You can, to a certain extent, control this effect by making some of the exposure through a filter or fabric and then removing this and making the rest of the exposure as a normal image. Diffusing the image is like toning; it is far better to begin experimenting yourself than for me to give a long list of 'possibilities'.

Printing with a texture screen

You can achieve some interesting textures by placing a screen over the printing paper and exposing through this. A good hunt around the darkroom will normally reveal some possibilities – the acetate sleeve from a portfolio can be used for example, as these tend to have a slight texture to them and give a gentle, slightly reticulated effect. A piece of frosted glass will give a dramatic but interesting effect – you can also create a grain screen to add a very coarse grain effect to a print. I made mine by exposing a few frames of Kodak 2475 recording film on a lightbox I developed as normal and then blew the negative up on my enlarger until I reached the grain size that I wanted. I then exposed the negative on to a sheet of 10 x 8in. negative film and processed this normally. If you then lay this over standard 10 x 8in. paper any negative will look as though it has been taken on an incredibly fast film – contrast, tonal range and acutance will be vastly superior though!

It is also possible to create texture by using a screen in conjunction with the negative. By placing a suitable piece of material in contact with the negative emulsion and exposing through this combination you can achieve some very different results – the material used to make frosted negative bags is very effective, while a piece of thin tissue paper also works well giving a more diffused image. It is possible to buy ready-made screens for 35mm negatives, but it is better and more satisfying to make, or to find, your own.

A range of materials used to create texture and diffusion
effects during printing.

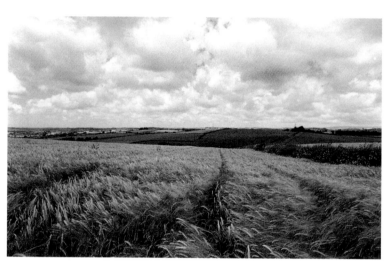

Print developed in the normal way

+10 secs

overall +15 secs

Print: The Field

To capture this sweeping field I used a very wide angled lens. This helped to give the scene a dramatic appearance, while an orange filter accentuated the clouds.

Technical Details
35mm SLR camera with a 24mm lens fitted with an orange filter. Exposure was 1/60 second at f16. Ilford HP 5 ISO 400 film developed in Ilfosol-S at 1 to 9 for 6 minutes.

Print Details
Ilford Multigrade IV resin-coated paper with a warm tone, developed in Multigrade developer, 1 to 9, for 60 seconds. Exposure time was 15 seconds at f8 with a contrast of grade 4. I gave the sky an additional 10 seconds exposure. I used my diffuser enlarger with a variable-contrast head.

Effect Details
At the printing stage I used a diffusion filter to soften the image. This also helped to give an illusion of movement to the wheat in the foreground. The filter I used was a Zeiss Softar IV, which was placed directly under the enlarger lens for the total duration of the exposure.

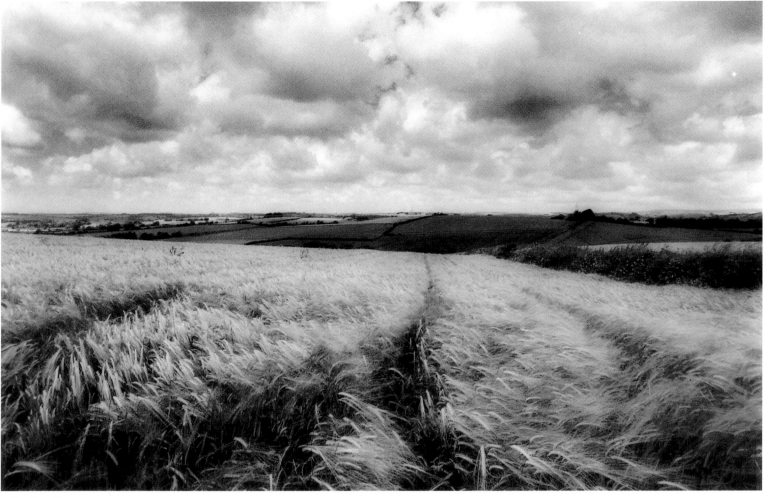

Julien Busselle

Print: Vine covered window

This window looked stunning when I came across it in a small French village the name of which I have long forgotten. The vines and the building's derelict appearance added a certain charm. I shot this from a low viewpoint, which threw the focus out at the top of the vines, helping to create some mystery.

Technical Details
35mm SLR 28–70mm lens. Exposure was 1/30 second at f16. Ilford XP2 ISO 400 film developed in C-41 chemistry.

Print Details
Ilford Multigrade IV resin-coated paper, warm tone. Exposure time was 22 seconds at f5.6 using a grade 4 contrast filter. I gave 10 seconds additional exposure to the left-hand side just to darken it down a little using a diffuser enlarger. Processing was in Multigrade developer at a dilution of 1 to 9 for 60 seconds.

Effect Details
The effect here is quite subtle – I only wanted to enhance the image slightly by giving the window an aged, crumbly look. To create this effect I took a piece of slightly frosted material cut from a negative bag, and sandwiched this with the negative. The end result is exactly as I had hoped. What I wanted to avoid was the effect being too noticeable; had the image had more mid tones, then this would have been the case and the subtlety would have been lost.

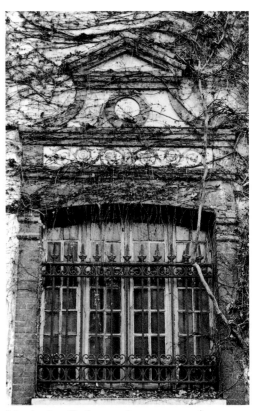

Print developed in the normal way

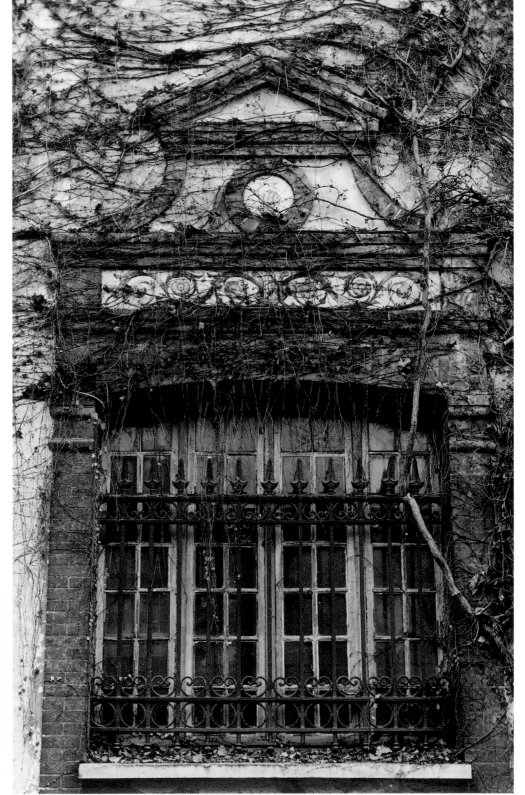

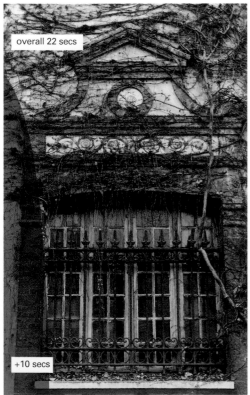

overall 22 secs

+10 secs

Julien Busselle

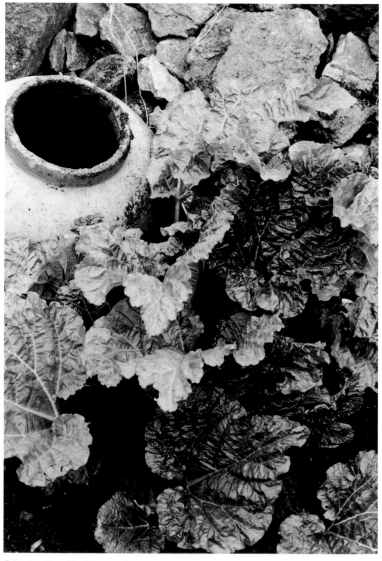

Print developed in the normal way.

Print: Rhubarb

I created this image for a cookery book. A search of a number of local allotments was called for before the image fell into place with all the right ingredients. Although the picture was taken on a fine-grained film, I needed the final image to have a more earthy look to it. Eventually I made a grain screen to give a 'gritty' effect to the print.

Technical Details
6 x 4.5cm SLR camera with an 80mm lens. I gave an exposure of 1/60 of a second at f16 on Ilford XP2 ISO 400 film. Although this film is fast it has very little grain, but it does feature a lovely tonal range. It was developed in standard colour negative chemistry (C-41).

Print Details
Exposure time was 42 seconds on Ilford Multigrade IV RC paper, using a diffuser enlarger with an aperture of f5.6. A little shading (10 seconds) was given to the bottom of the print. Contrast was grade 4 and the print was processed in Multigrade developer at a dilution of 1 to 9, for 1 minute.

Effect Details
I used a grain screen on this print to get the look that I wanted. The screen was placed directly in contact with the paper, and the exposure made as normal. An extra 20 seconds needed to be added to the exposure time, because of the density of the screen.

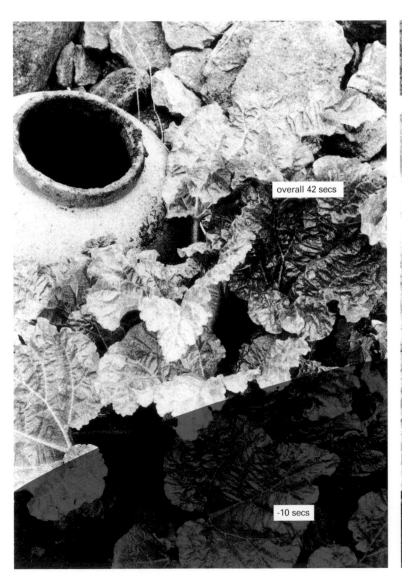

overall 42 secs

-10 secs

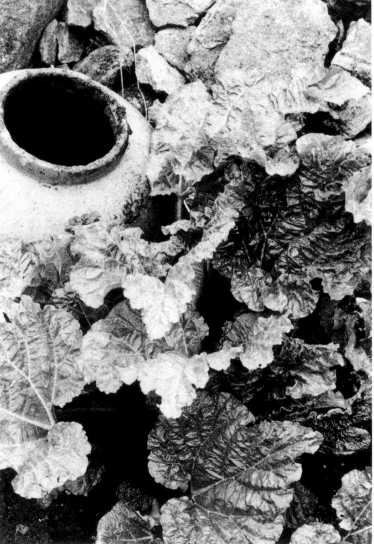

Julien Busselle

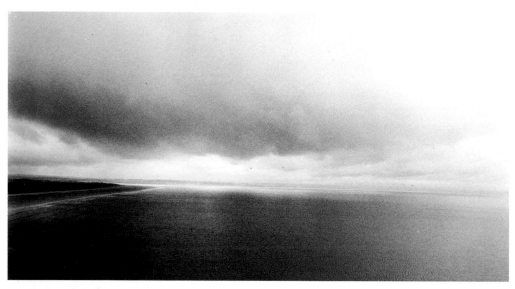

Print developed in the normal way.

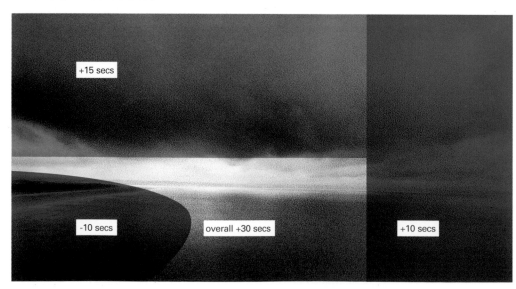

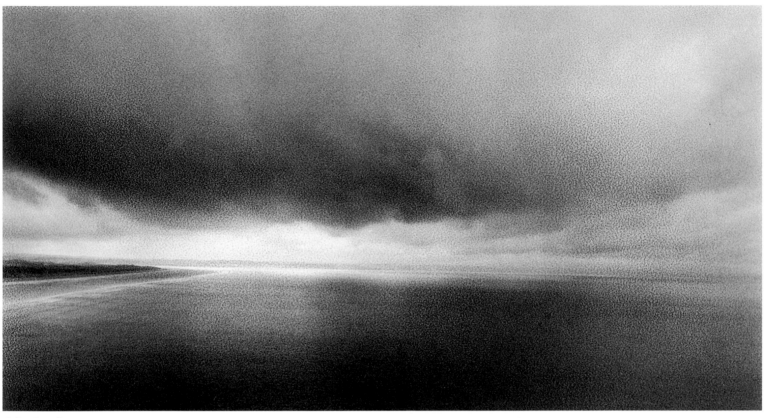

Julien Busselle

Print: Summer storm

I saw this band of rain clouds moving in across one of the surf beaches where I live. It was a humid summer's day, and the sea was unusually calm. The atmosphere was quite intense, but the whole scene was difficult to capture because of the limited tones and flat sea.

Technical Details
35mm SLR camera with a 24mm lens fitted with an orange filter. Exposure was 1/60 second at f16. Ilford HP 5 ISO 400 film developed in Ilfosol-S at a dilution of 1 to 9 for 6 minutes.

Print Details
Ilford Multigrade IV resin-coated paper. The whole scene was given 30 seconds exposure at f5.6, during which I held back the point of land and breakers for approximately 10 seconds. An additional 15 seconds was given to the sky with a further 10 seconds to the whole right-hand side of the print. I used my diffuser enlarger with a variable-contrast head set at grade 5.

Effect Details
I added the texture effect to the print by exposing the paper through a slightly frosted portfolio sleeve which I placed directly on top of the paper to bring the pattern into focus. The texture relies upon a fairly flat scene with plenty of mid tones to allow it to show up.

Section 4

Using Lith

The effect created by processing prints in lith developer is a personal favourite. You never really know what you will get, but this is part of the appeal for me. If you only try one effect from this book make it this one; it makes you rediscover the darkroom and will add another dimension to your work.

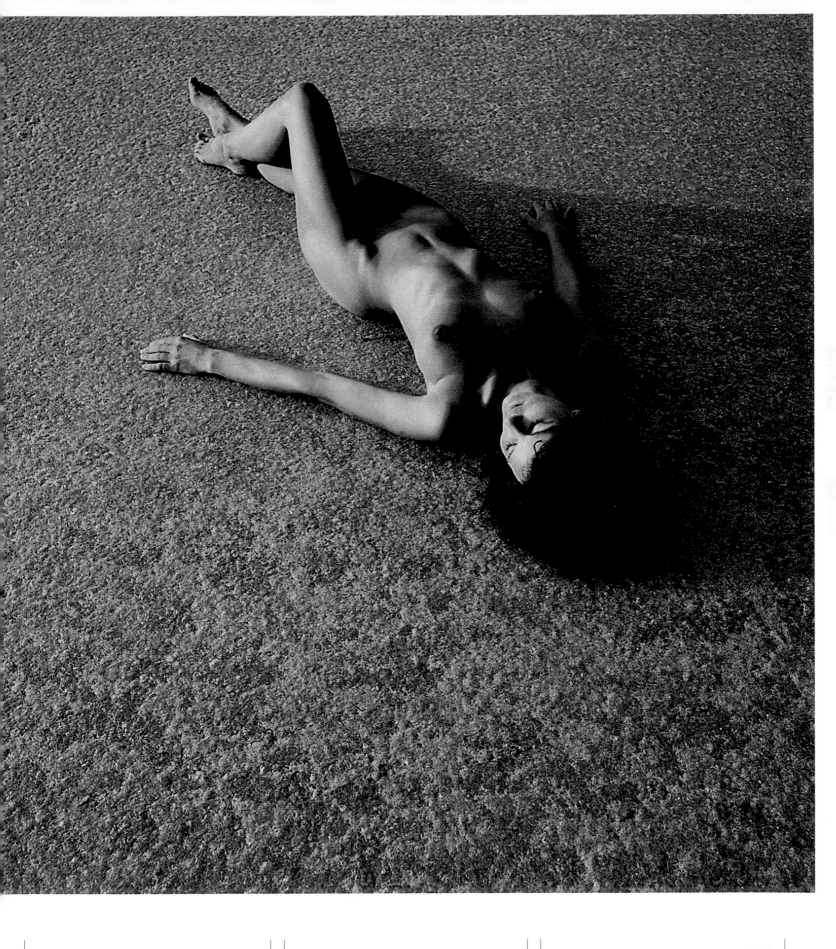

01. Using Lith

To get the best out of the lith process, you have to be prepared to experiment, and for that reason it should be stressed that the best way to learn and to produce images is to get stuck in and not to bother too much with the technicalities. Some papers work better in the lith developer than others, whilst some don't seem to work at all. Exposure is less important than the time spent in the developer, although a shorter exposure tends to produce a more contrasty result. The time spent in the developer will vary enormously and the performance of the developer itself will change quite quickly as its freshness fades so I really wouldn't bother with tests at all. Colours will change as the print dries, so try to assess a dry rather than a damp print.

Developers and papers

Lith developer comes supplied as a two-part kit which is then mixed together to form a one-bath developing solution. For general purposes mix together 100ml each of parts A and B with 1800ml of water. Temperature is not crucial but 20 degrees C is a good point to aim for. Choosing which paper to use is not so straightforward: the best ones will be found through trying some out for yourself, but I can recommend the following as a starting point.

Kentmere Kentona: I think this paper is so good for my lith work that I find it hard to use others. It produces a lovely range of hues from browns to wonderful peachy golds. It also works superbly with gold and selenium toners.

Sterling Premium F Lith: This is a true lith paper, and as such will produce the strongest lith-style image. The grade of the paper can be varied with the most tones appearing at grade 2. Expect cold blacks with warm sepia mid-tones. This paper is again responsive to gold and selenium toners.

Forte Polywarmtone FB: This paper gives a range of tones from a red-brown to a deeper coffee-brown. As with the other papers mentioned here, it's good with gold and selenium toners, but great care must be taken during development as this paper is prone to fogging. A dark red safelight needs to be used, and even then caution should be taken, with exposure and the safelight kept to a minimum. There are many other papers that perform well in lith developer. Try your favourite or that old box that you could never get along with for normal printing – you never know!

These Kentmere Kentona prints illustrate the variety of tones and contrast achieved by varying exposure and development.

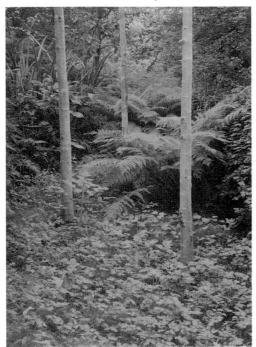

This print was given an exposure of 60 seconds and developed for 4 minutes.

This print was given an exposure of 60 seconds and developed for 5 1/2 minutes.

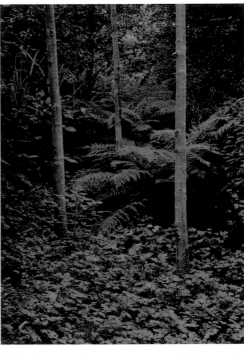

This print was given an exposure of 30 seconds and developed for 6 minutes.

The development process

Using the developer in the dilutions previously mentioned is the most straightforward way to begin printing lith, but after your first session keep the old developer. By now it will be slightly stale, not fully exhausted, and it will have begun to oxidise and to become brown in appearance. This is known as 'old brown' and can be added to fresh developer to achieve what is sometimes a much better effect. Simply add 100ml each of parts A and B and 'old brown' to 1800ml water.

Expose your chosen paper and place the print in the lith developer: patience is needed here as the image will take quite a long time to begin to appear. It is best to pull up a chair and resist the temptation to bin the print as it some- times seems as though no image will ever appear. Rest assured that it will, but it could take several minutes. Watch the print carefully – ignore light tones and concentrate on the mid-tones and shadows – and the time to remove the print from the developer is when the shadows have reached the density you are happy with. The shadows can increase in density at an alarming rate, completely out of proportion to the initial wait for any sign of the image, so be extra vigilant. Get the print into the stop bath as quickly as possible and then fix and wash as normal. The exposure of the print is far less important than in conventional printing. It is the time in the developer that will have the greatest effect on the image.

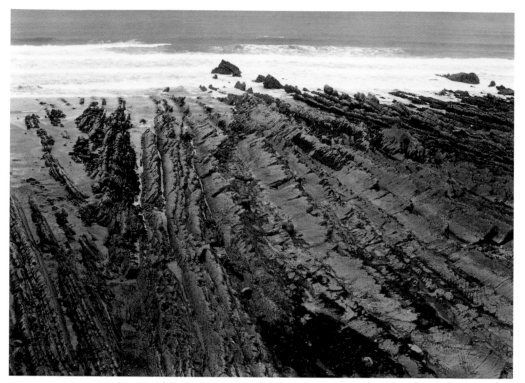

Print without effects

-8 secs

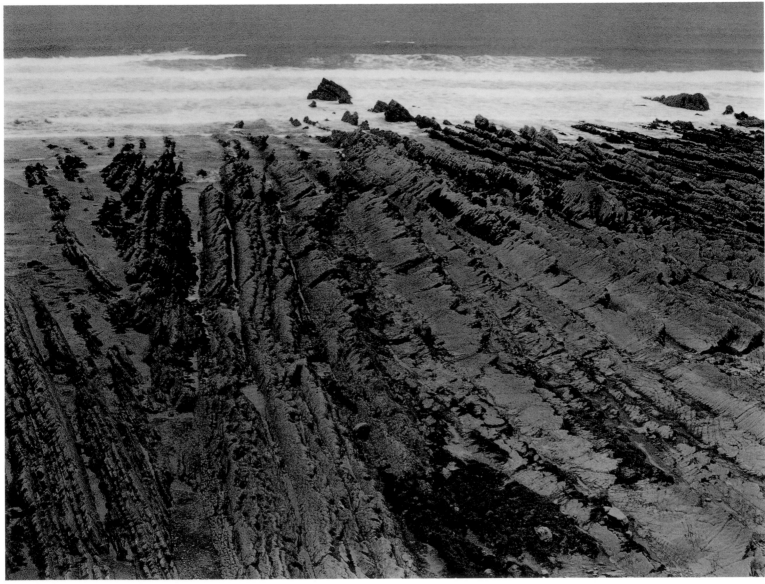

Julien Busselle

Print: Welcombe Mouth

I came across this stunning beach quite by accident. I had decided to risk my tin-pot car on a very uninviting rough track and I would have given up halfway down but couldn't find anywhere to turn. At the end of the track was this amazing piece of coastline – remote enough to provoke a feeling that you were intruding. The only other people on the beach were two surfers, and I had to wait for some time until they were out of frame.

Technical details
6 x 4.5cm SLR camera with a 55mm lens. Exposure was 1/15 second at f22. Ilford XP2 developed in standard C-41 chemistry.

Print details
Kentmere Kentona paper developed in Novolith chemicals. I used 100ml each of parts A and B plus 1800ml water. The paper was exposed for 25 seconds and developed with constant agitation; the image began to appear at 4 minutes and I pulled the print from the developer at 6 minutes as the image was gaining density very quickly at this stage. The enlarger was a diffuser type and I used an aperture of f5.6. I shaded the rocks to the left for 8 seconds.

Effect details
This is a 'classic' lith print – the Kentona paper nearly always gives a rich pink and gold tone. As I mentioned before, the use of lith owes much to experimentation, but with the right image it becomes a very attractive technique and in this case I felt that the print needed no further effect.

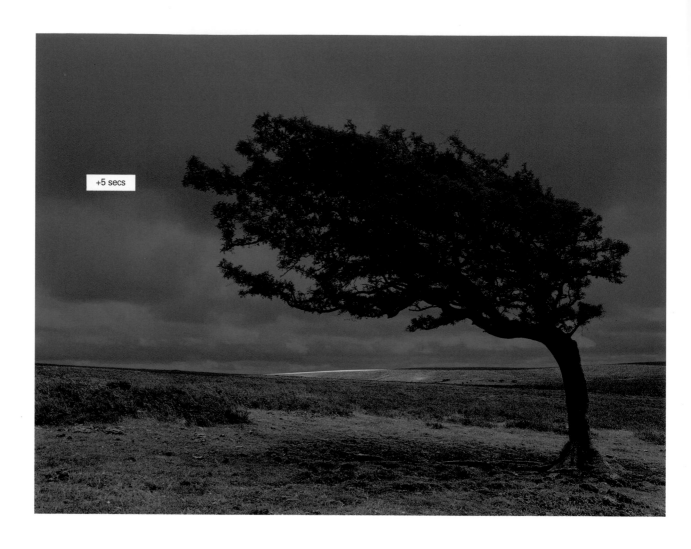

+5 secs

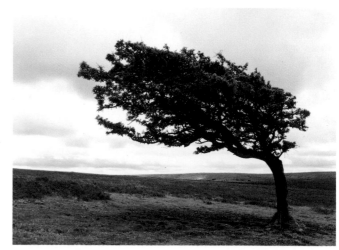

Print without effects

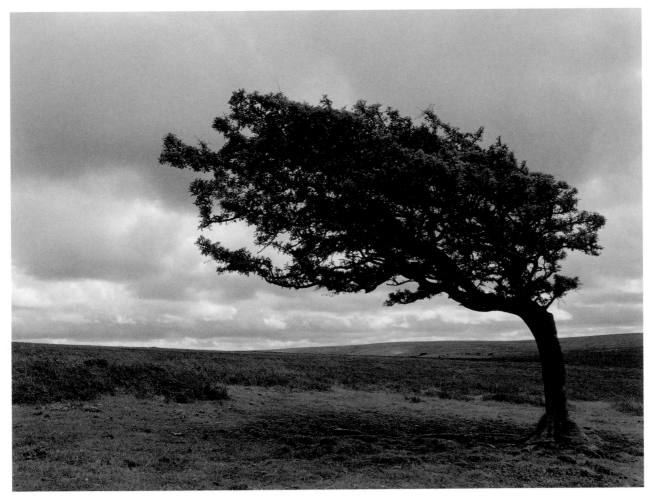

Julien Busselle

Print: Lone tree, Exmoor

This is perhaps my favourite tree on Exmoor, and I have a wide variety of pictures of it to prove it! On this occasion I opted for a straightforward approach as the light was gently diffused and the cloud structure was quite subtle. The shot was a little undramatic to work well as a straight print, but I knew that it was ideal for a toning technique, preferably on a lith print.

Technical details
6 x 4.5cm SLR camera with a 55mm lens fitted with an orange filter. Exposure was 1/30 second at f16. XP2 developed in standard C-41 chemistry.

Print details
Kentmere Kentona paper developed in Novolith chemicals. I used 100ml each of parts A and B plus 100ml of 'old brown' (this is the stale developer from a previous lith printing session), and 1800ml water. The paper was exposed for 20 seconds and placed in the developer. I used gentle but constant agitation; the image began to appear at approximately 3 minutes, and I continued the development until the image reached the density I wanted at 5 3/4 minutes. The enlarger was a diffuser type and I used an aperture of f5.6. In addition I gave an extra 5 seconds exposure to the sky.

Effect details
When the print had dried I felt that it needed a slight 'lift'. Selenium toner was ideal for this, giving me a little intensification of the image, particularly in the leaves of the tree. The colour shift from the classic pinky gold of a straight lith with the Kentona paper, to a more purple colour was achieved by removing the print from the selenium before the complete tone had taken place achieving a result that was a split tone. If I had left the print longer in the selenium toner the colour change would have removed the pink tone altogether. The print on the following pages is an example of what happens when the lith print is left to tone in the selenium bath. I used Kodak's selenium toner at a dilution of 1 to 20 for 3 minutes.

Tip: As with all toning and archival printing, proper fixing and washing must be undertaken. One major problem when washing consecutive prints in one wash is that the first print is effectively given an additional dose of dilute fix each time another print is added. Although two bath washes go some way towards overcoming this problem, the best answer is to use an archival print washer. All prints used in these washers are kept separate and therefore don't contaminate each other, and as a bonus they take up less space than a large wash dish and consequently save water.

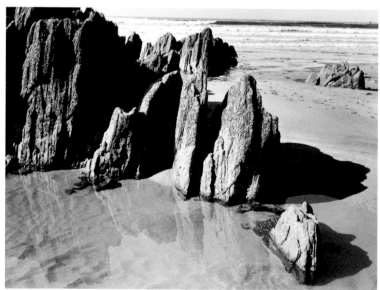

Print without effects

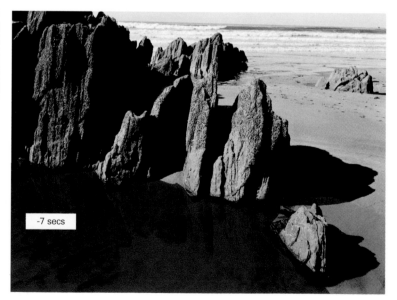

-7 secs

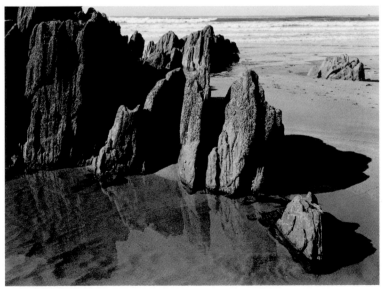

Julien Busselle

Print: Rocks

This study of rock formations was taken on a bright day, and I thought I might have problems with contrast. Consequently I waited for a little cloud cover to diffuse the light slightly before taking the shot. The ripples in the wet sand in the foreground were the main feature for me, and I based my exposure on this area.

Technical Details
6 x 4.5cm SLR camera with an 80mm lens. Exposure was 1/60 second at f22. Ilford XP2 in C-41 chemistry.

Print Details
This print was made on Kentmere Kentona paper developed in Novolith chemicals. The exposure was 40 seconds at f5.6 and I shaded the wet sand in the foreground for 7 seconds, this was done to darken the other areas slightly rather than to lighten the wet sand. The dilutions I used for the lith developer are the same as the previous page, and I removed the print from the chemicals after 6 minutes. Great care was taken to thoroughly wash the image as I was intending to tone the print in selenium toner. I used a diffuser enlarger with a variable-contrast head.

Effect details
I placed the print in a selenium bath at a dilution of 1 to 20. I would normally tone to a stage where elements of the original lith print and the selenium are apparent. On this occasion, however, I chose to let the print go further in the selenium bath, and the slight steely purple effect is the result.

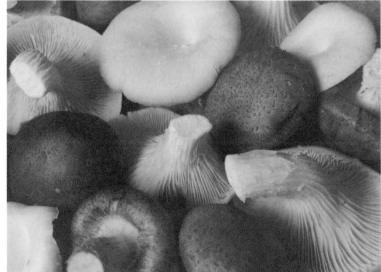

Print without effects

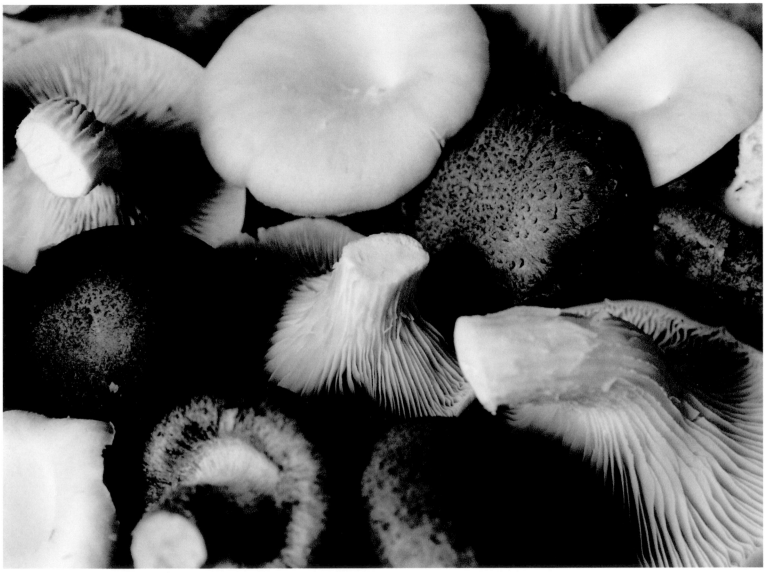

Julien Busselle

Print: Mushrooms

This is a photograph that I took some time ago, and it was used as an illustration in a book. The print I produced at the time was made on a warm-tone paper and then toned with Agfa Viradon to create a brown image. When I came across the negative recently I just had to make a new print and put it through the lith process, even though I knew the end result would be harsh and quite different from the original concept.

Technical Details
6 x 4.5cm SLR camera with an 80mm macro lens. Exposure was 1/60 second at f16. Film choice was Agfapan APX 100 (ISO 100) developed in Agfa Rodinal for 5 minutes at a dilution of 1 to 25.

Print Details
Kentmere Kentona fibre-based paper grade 2. I gave an exposure of 35 seconds at f5.6. No shading was used on this print so I have also shown here the first print that I made, which was given a shorter spell in the developer, for comparison.

Effect details
Both prints were developed in Novolith chemicals with 100ml of parts A and B diluted with 1800ml of water. Print A was removed from the developer after 5 minutes whilst print B was left for 7 minutes for the shadows to build up. Initially I wanted a softer approach to the print but after the disappointing result with print A, I decided to let the second print become a harder, darker image altogether. No further toning or effect was added.

Print: Oranges on Farmhouse Steps

This was taken during an assignment to illustrate a cookery book. These oranges had been put to one side on the steps for use later. I liked the relationship between them and took a couple of shots for portfolio use, but the publisher insisted on their use in the book as a straightforward black-and-white image. It wasn't until some considerable time later that I tried the negative as a lith print to add to my portfolio.

Technical Details
6 x 4.5cm SLR camera with a 55–110mm lens. Exposure was 1/8 second at f16. Kodak Tri-X ISO 400 developed in Ilford Ilfosol-S at a dilution of 1 to 9 for 10 1/2 minutes.

Print Details
Kentmere Kentona fibre-based paper grade 2. I gave an exposure of 30 seconds at f5.6. I shaded the wall for 6 seconds to 'knock back' some of the marks on the plaster.

Effect Details
I added a slightly diffused appearance to the print by using my Zeiss Softar filter under the enlarger lens during the full exposure time. The print was then developed in Novolith chemicals at a dilution of 100ml each of parts A and B to 1800ml of water. The image took 5 minutes to reach the required stage.

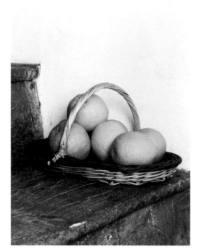

Print without effects

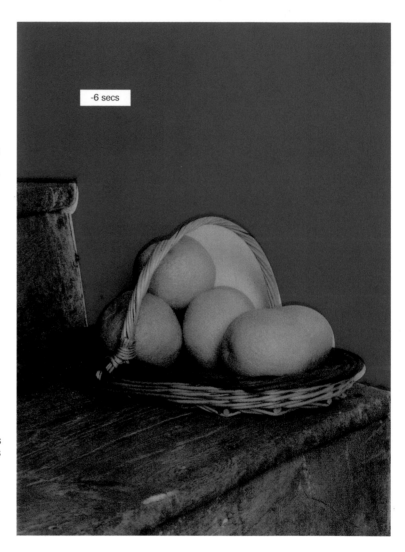

-6 secs

Tip: When going through negatives to use with the lith process, it can often pay to use one that is thinner than normal, as these seem to work particularly well. Avoid subjects or negatives with excessive contrast, as the shadows will become too dense before the rest of the image catches up.

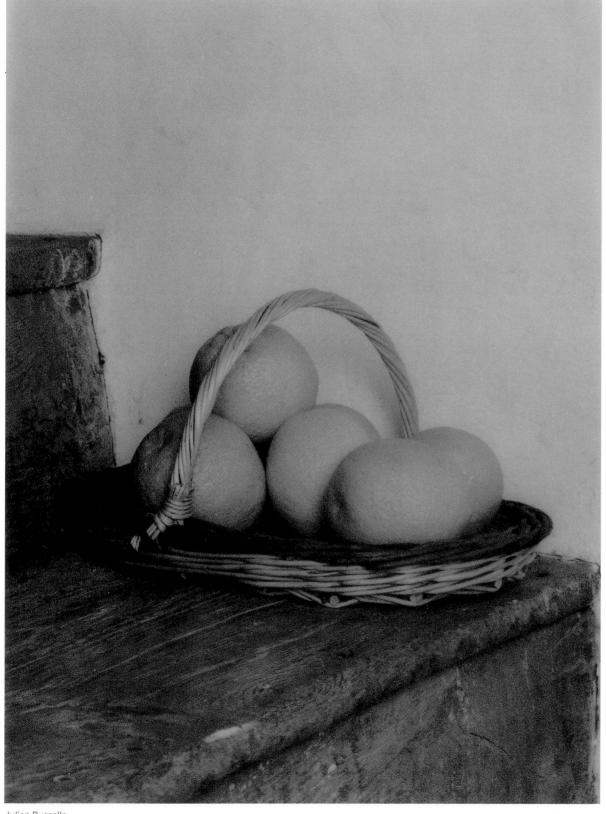

Julien Busselle

-5 secs

The Potting Shed

I occasionally photograph gardens and recently have switched from an approach that relied on the capturing of rich saturated colours, to a black-and-white simplistic view that places the emphasis on texture and light. This shot was taken on an overcast day, which enabled me to record detail from inside the potting shed itself as the reflections were at a minimum. I love this picture for its timeless appeal.

Technical Details
6 x 4.5cm SLR camera with an 80mm macro lens. Exposure was 1/15 second at f22. Ilford XP2 developed in standard C-41 chemistry.

Print Details
Once again I used Kentmere Kentona paper. I admit to being completely addicted to this paper for my lith printing and although I do use others, most people seem to always pick out the prints made on this paper. I gave an exposure of 25 seconds at f5.6, during which I gave a brief shading of 5 seconds to the window to keep some detail in the flowerpots that otherwise would have been a little lost in the shadows.

Effect Details
I developed the print in Novolith chemicals at my standard dilution. The image began to appear after 3 minutes and I pulled the print from the developer after 4 minutes. I did this as I deliberately wanted to retain a soft, vintage look to the print and I felt a harder print would have lost the character of the original shot. I was happy with the way it looked, and decided that no further effect was required for this image.

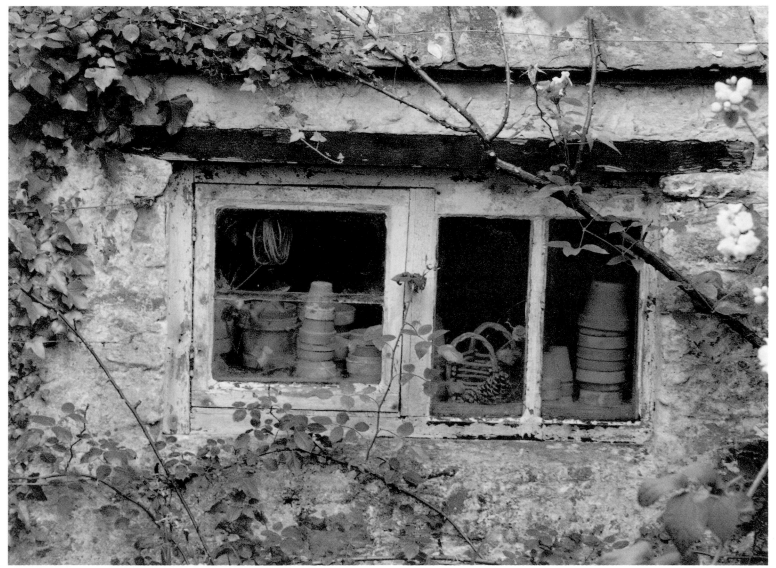

Julien Busselle

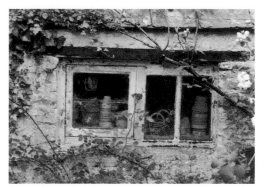

Print without effects

Alternative Processes

Some of the alternatives to conventional printing and toning are processes that have been in use for over 150 years. The popularity of these is on the increase as photographers rediscover the quality and appeal of vintage techniques. If you feel like reaching back into the past to create something very personal and distinctive, then the simple processes in this chapter may be just what you are looking for.

01. Alternative Processes and Hand Tinting

The alternative processes here have been chosen for their simplicity. Indeed both the Argyrotype and Cyanotype are available in a very easy-to-use kit form made by Fotospeed. One point worth mentioning is that exposure times and methods for these processes can be very long, and this makes any dodging and burning in impossible. For this reason it is best to use a negative that will give a good 'straight' print if possible. Hand tinting is normally done on a conventional print, but if the mood takes you…!

Cyanotype
This process produces a rich blue image. A duplicate negative, to the size you want your final print to be, has to be made from the original, since Cyanotypes are contact prints. The kit I used here, and the one I recommend, is manufactured by Fotospeed and is both thorough and easy. This kit is an update of the traditional process, and is more sensitive to UV light and therefore easier to expose. The paper used for printing must be coated in the sensitiser solution and left to dry in the dark for 1 hour, and afterwards used fairly promptly. The exposed paper is processed in water, which will need to be changed frequently to ensure the best results.

Argyrotype
This process will give you a brown image. Once again you'll need to make your print by the contact system, exposing the image by UV light (daylight is best) on to the coated paper. Using Fotospeed's Argyrotype kit, the technique for coating the paper is a modern relative of the Kallitype, and it is the same as that for Cyanotype. Once exposed, the paper is processed in running water for 5 minutes or so and then fixed.

Gum bichromate
A slightly trickier process than the others, gum bichromate is still well worth the effort. The colour of the finished print is dependant on the pigment that you use when mixing the emulsion together. Details of how to prepare the emulsion for this process are on page 88–89, otherwise coating the paper and processing are virtually the same as for the other processes here.

Tips for success

1 Get a good quality, large negative for the contact. Overdeveloping the negative by 70%–80% is normally recommended, so that a suitable density range is produced. The computer is an excellent alternative to the rather tedious process of making a negative from a negative. Simply scan your negative, make any adjustments on screen and print out on to OHP film. The result is then suitable to use as your negative.

2 Make sure the paper that you decide to coat with your emulsion is suitable for the process – a weight of 120–300gsm is about right. Many artists' papers are suitable but Arches Platine, Hollingsworth Kent and Whatman watercolour are all particularly good, and will make an excellent starting point.

3 Coat the paper with the solution as evenly as possible – using a glass rod is more economical and will give even results on smooth papers, but a brush feels more artistic!

4 Allow the paper to dry thoroughly and use the treated paper as soon as possible after the application, certainly within a few hours.

5 Be prepared to try different papers and negatives. Some papers and subjects work better than others.

Hand tinting

Although not strictly a process, this is a real alternative to conventional toning techniques. Emma Delves Broughton, whose images appear in this book, is particularly good at achieving a superb effect with this method. Patience, care and artistic ability all help but the secret here is to keep things subtle; so many hand-tinted photographs end up like a painting-by-numbers picture. Emma's technique is superior to many others, and her description of her technique is on page 90–91. You can use dyes, inks or watercolours for tinting but always match brush size to the area which needs to be covered. Work slowly with a steady hand and some absorbent material close to hand.

02. Alternative Processes – Cyanotype

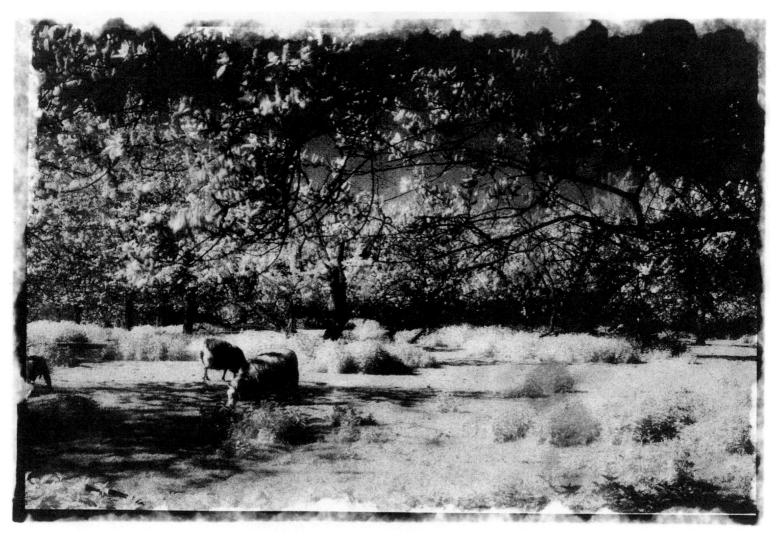

Julien Busselle

Print without effects

Print: Spring orchard

This unusual picture of sheep in an orchard was taken on Kodak infrared film. This gives a 'luminosity' to the foliage and helps to create a dream-like quality. I had intended to make a conventional print and to sepia-tone the image, but changed my mind and decided to try it as a Cyanotype.

Technical Details
35mm SLR camera with a 28–70mm lens. Exposure was 1/125 second at f8. Kodak 2481 infrared film developed for 6 minutes in Kodak HC 110 developer dilution B which is 1 part developer to 31 parts water.

Print Details
For this print I used the Cyanotype kit by Fotospeed. The first step in this process was to make a 10 x 8in. negative from the original. Since this is then used to produce a contact print, the large negative gives a pleasing size of image. The printing paper (I used Bockingford 190gsm water-colour paper) was coated with the single solution and allowed to dry in the dark. The negative was placed on to the paper and held flat by a scrupulously clean sheet of glass. The exposure was 5 minutes, using sunlight as the light source. The exposed print was simply developed in several water baths until all the yellow background had disappeared.

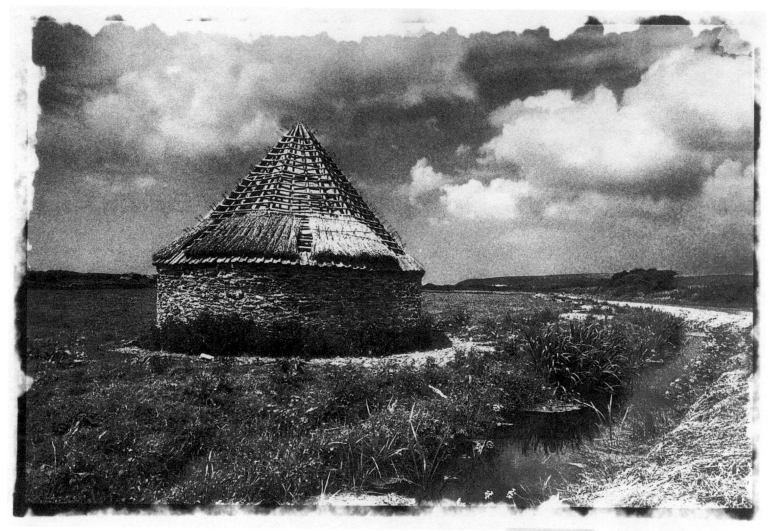

Print without effects

Print: Marshland

I took this on some local marshland. The circular barn in a very flat landscape had appealed to me for some time, but it was difficult to get a good picture as the field is normally full of very large heifers!

Technical Details
35mm SLR camera with a 28–75 mm lens. Exposure was 1/125 second at f8. Kodak T-Max 100 developed for 6 1/2 minutes in T-Max developer diluted 1 to 7 at a temperature of 24 degrees C.

Print Details
This was made using the Agyrotype kit from the Fotospeed range. As before I had to make a 10 x 8in. negative from the original, and then I coated the paper with the solution supplied, allowing it to dry for 1 hour in the dark. I used Bockingford 190gsm watercolour paper again and made what is essentially a large contact print, using a 5mm thick sheet of glass. This took 6 minutes using an UV lamp. The print was processed in running water and fixed using the powder supplied.

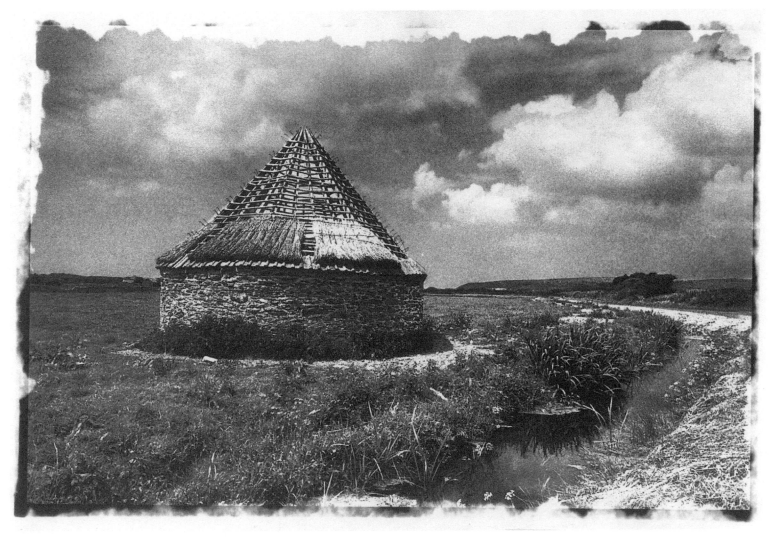

Julien Busselle

Print: Forest, Jura mountains, Alsace, France

This was originally taken on colour transparency film, but it had all the qualities to make an equally striking black-and-white image. Rather than produce a conventional print I chose to try the image as a gum bichromate, which helped to move it one stage further away from the colour original.

Technical Details
35mm SLR camera with a 35mm lens. Exposure was 1/8 second at f16. Colour transparency ISO 50 film, from which a black-and-white negative was made.

Print Details
The first step in this process was to size the paper (Hollingsworth Kent). This is a process that adds water resistance, so that sensitiser will sink into the paper when you brush it on; I used a mix of 28g powdered gelatine to 250ml water, allowing this to set and then remelting it before coating the paper with the mixture. This must be thoroughly dry before the sensitive emulsion is applied. For the emulsion I made two separate, saturated solutions of powdered gum Arabic and potassium bichromate. Equal quantities of both were mixed together and some powdered watercolour pigment was added. Any colour can be used, but for this I opted for burnt sienna. I coated the paper with the solution and allowed this to become completely dry before making a contact print from the negative. Exposure time was approximately 10 minutes using a UV lamp. The exposed paper was processed in running water until the excess pigment was cleared from the highlight areas.

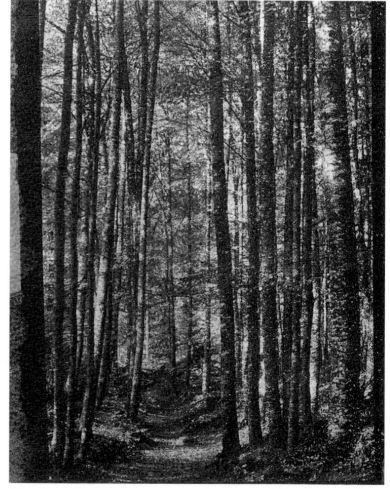

Print without effects

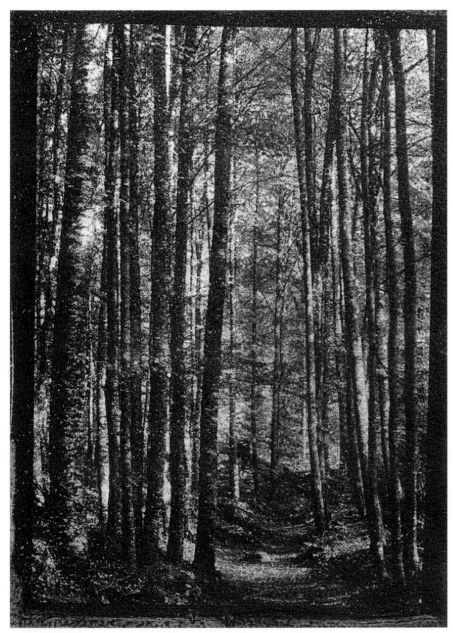

Michael Busselle

05. Hand Tinting

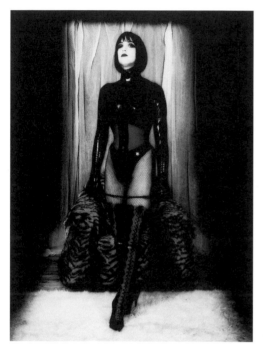

Print without effects

overall 24 secs +22 secs

+12 secs

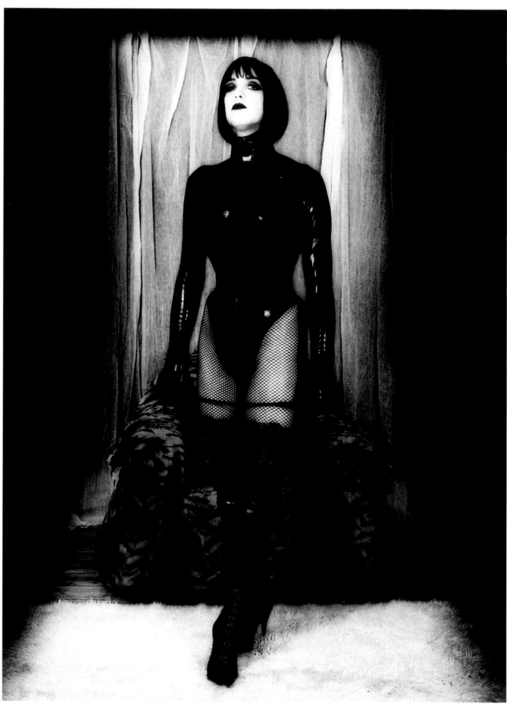

Emma Delves Broughton

Emma Delves Broughton

Print: Katrina, 1997

Katrina has an abundance of fabulous outfits – we have worked together
photographing many of them over the years and this was taken during the
first session.

Technical Details
6 x 6cm TLR camera with an 80mm lens. Exposure was 1/250 second at
f5.6. Kodak T-max 100 film uprated to ISO 400 and developed for 11 min-
utes in Kodak T-max RS at 24 degrees C.

Print Details
I used Ilford Multigrade FB paper for this print, giving an exposure in two
parts – 12 seconds with the exposure through tracing paper and a further
12 without. I used a contrast filter of 2 1/2. The rug was given an additional
12 seconds and I created a 'curtain' by burning in the sides and top for 22
seconds at f5.6 – this was done without the negative in the carrier. The
print was developed in Multigrade developer, 1 to 9, for 2 minutes.
Enlarger type was a condenser.

Effect Details
The print was initially selenium toned. For the colouring the print was
soaked in water into which a few drops of wetting agent were added. The
print was then removed and placed on a flat surface, where a chamois
was used to remove any excess water. Coloured dyes were used for the
tinting; a small natural sponge and a large sable brush are best for the
larger areas, but a very fine sable was used to highlight colour in the eye
make-up and lipstick. Gently wiping the surface of the print as you go
removes excess water and dye, helping to prevent 'bleed'.

Section 6

Practical Techniques

The prints in the following section are all accompanied by technical details and the photographer's personal viewpoint. The idea is that these images will not only serve to inspire, but that the photographers themselves will explain the stories and techniques behind them. It's an alternative to the 'now you do this' scenario, and it shows that there are many different approaches to the challenges that face a photographer, and many ways of producing the perfect print.

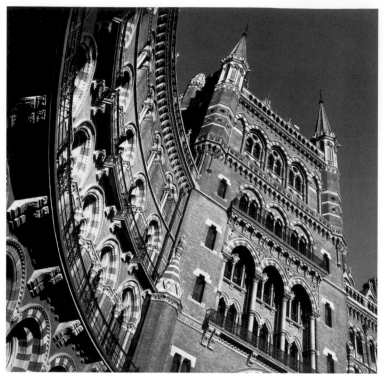

Print without effects

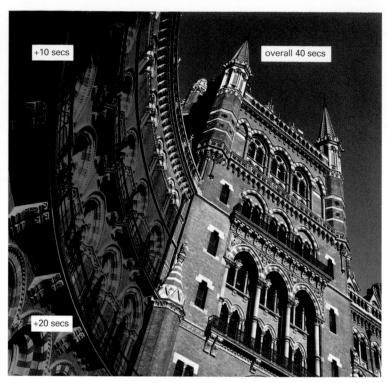

+10 secs

overall 40 secs

+20 secs

Print: St. Pancras

I deliberately chose a dramatic angle for this shot, highlighting the wonderful curve within the architecture. The light quality on this particular day was perfect for the shot, being quite contrasty but not overpowering. It was enough to give strong texture, while some shadow detail was still retained.

Technical Details
6 x 6cm SLR camera with a 60mm lens. Exposure was 1/250 second at f22. Kodak T-max 100 rated at ISO 100 developed in T-max developer at a dilution of 1 to 4 for 6 1/2 minutes at 24 degrees C.

Print Details
I used Ilford Multigrade IV FB warm tone for the print, giving an exposure of 40 seconds at f8. The print was processed in Agfa Neutol WA developer for 2 minutes. I used a condenser enlarger with a contrast filter of 3, giving an extra 10 seconds exposure to the left-hand side of the print and a further 20 seconds to the curved area in the bottom left.

Effect Details
The print was toned in Agfa Viradon to give a warm, rich brown image. I simply left the print in the toner until it had taken on the depth of colour I wanted, which took approximately 4 minutes.

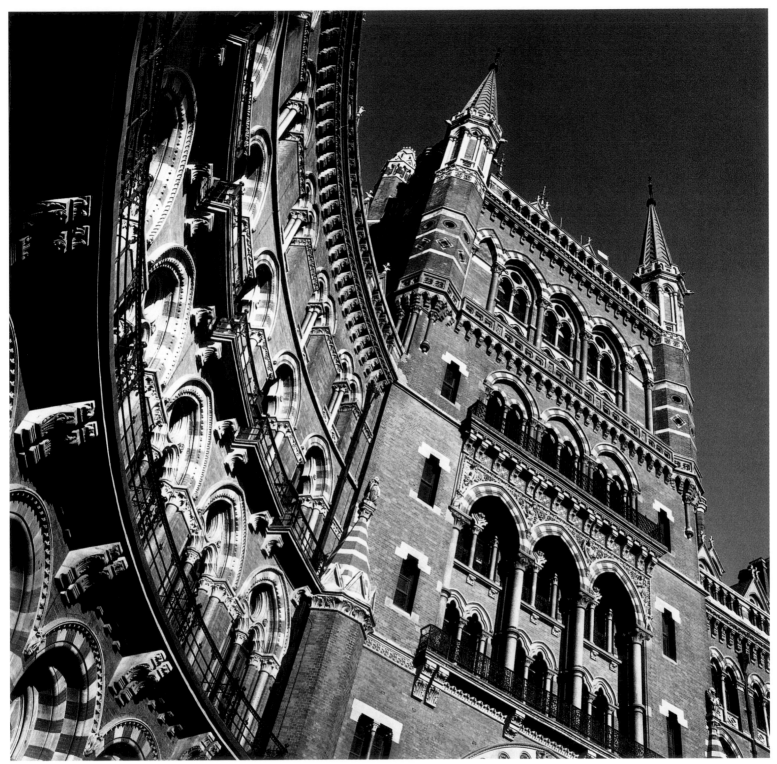

Matt Anker

Print without effects

-15 secs

-15 secs

overall 60 secs

Matt Anker

Print: Alan McGee, President of Creation Records

I took this shot during a studio session for Alan McGee's own PR use. At the time his record company, Creation Records, had just signed a number of bands such as Oasis and Primal Scream and the company was at the forefront of the independent labels. I had taken many photographs of the bands that were signed to Creation, and Alan requested a portrait based on the work that I had done with his bands. The idea of using the lith process as opposed to a more standard approach was partly due to the style that Alan had liked so much in the shots I had done for his bands.

Technical Details
6 x 6cm SLR camera with a 60mm lens. Exposure was 1/500 second at f16. Kodak T-max 100 rated at ISO 100 developed in T-max developer at a dilution of 1 to 4 for 6 1/2 minutes at 24 degrees C.

Print Details
The print was made on Process Supplies own-brand lith paper. Exposure was 60 seconds at f8 on a cold-cathode enlarger. The eyes were held back for 15 seconds each.

Effect Details
The print was developed in Novolith lith developer diluted 100ml A and B with 600ml water. The print was developed for 3 1/2 minutes in the Novolith chemicals, allowing the skin to achieve the right texture without losing the subtle highlights on the cheekbones.

Print without effects

Print: Bob Mould

This was taken in a hotel room, and the cramped conditions demanded the use of a low angle to avoid a cluttered and uninspiring background. This viewpoint also helped to make the subject more imposing. The use of a long lens foreshortened the distance between the subject's face and hand, and helped with the condensed, almost claustrophobic feel of the image. The highlight in the eyes was created by a softbox above the camera and slightly above the subject's eye level. By using a slow shutter speed I was able to record some ambient light which prevented the background from becoming too dark.

Technical Details
6 x 6cm SLR camera with a 120mm lens. Exposure was 1/30 second at f16. Kodak T-max 100 rated at ISO 100 developed in T-max developer at a dilution of 1 to 4 for 6 1/2 minutes at 24 degrees C.

Print Details
This print was made on Oriental Seagull fibre paper. I gave an exposure of 2 1/2 minutes at f5.6 as this paper is somewhat slow. I also gave an additional 30 seconds exposure to burn in the very top of the print and an extra 40 seconds to the very bottom. I used a condenser enlarger.

Effect Details
The print was processed in Novolith developer to create a classic lith appearance, with a development time of 5 minutes. In addition to processing the print in lith developer, I toned it in a copper toner for about 2 minutes until I was satisfied with the overall colour and effect.

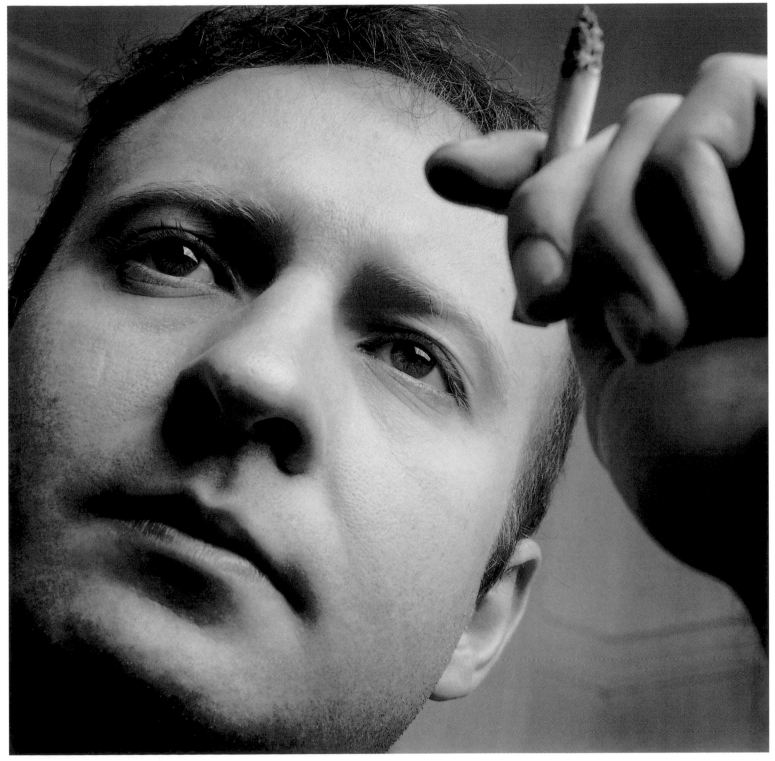

Matt Anker

Tip: When using lith you can increase contrast by reducing the exposure time and extending development. To reduce contrast work the other way – increase exposure and reduce development time.

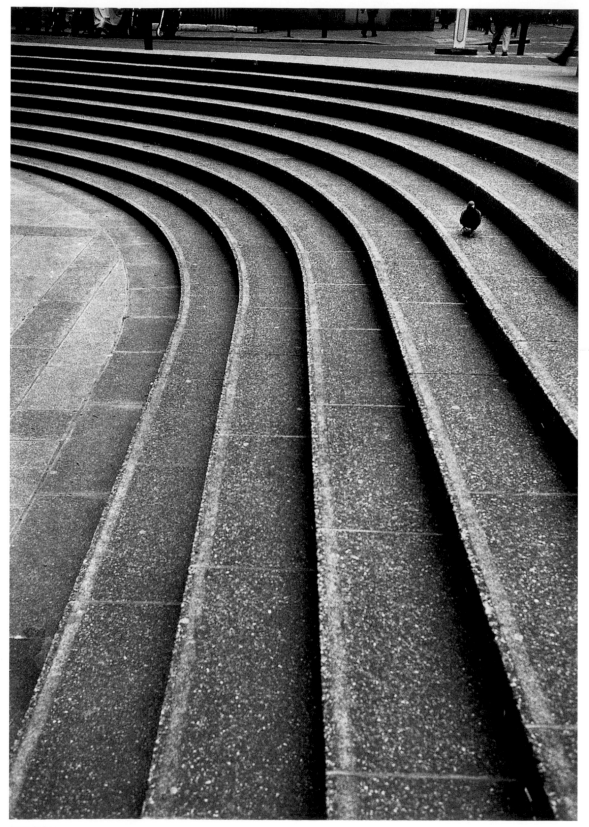

Matt Anker

Print without effects

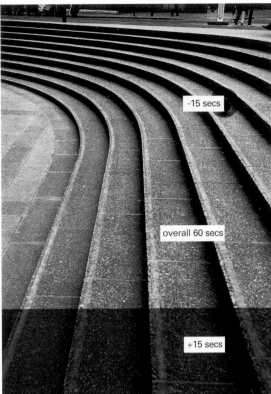

Print: Pigeon / Steps

The smooth, sweeping lines of the steps were what attracted me to this scene, and I took up a low viewpoint to exclude unwanted detail, leaving the eye to wander around the curves and patterns in the pavement. I delayed pressing my shutter until the pigeon had ambled into an interesting position.

Technical Details
35mm SLR camera with a 35mm lens. Exposure was 1/60 second at f5.6. Film stock was my usual – Kodak T-max 100 rated at ISO 100 and developed in T-max developer at 1 to 4 for 6 1/2 minutes at 24 degrees C.

Print Details
I used Ilford Multigrade IV FB warm tone for this print, giving an exposure of 60 seconds at f8, on a condenser enlarger. I held the pigeon back for 15 seconds and gave an extra 15 seconds to the bottom of the print.

Effect Details
The print was developed in Novolith chemicals – 100ml A and B to 600ml water. Development time was about 3 1/2 minutes.

Tip: Flashing is a technique that reduces contrast and allows more detail to be recorded in the highlights. Usually it is carried out prior to the main print exposure, and it is most easily achieved by giving a timed exposure to the paper under the enlarger without a negative in the carrier and with the lens stopped down. A few tests will help to familiarise you with what is, essentially, a simple process.

Print without effects

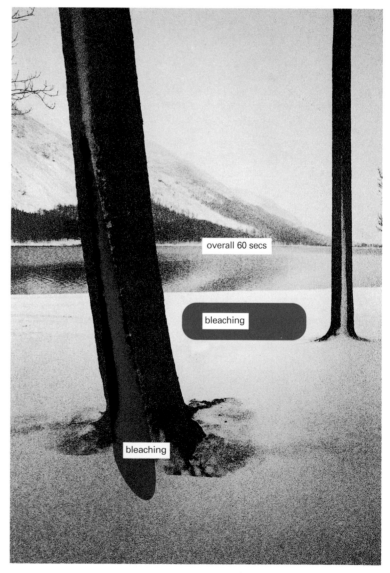

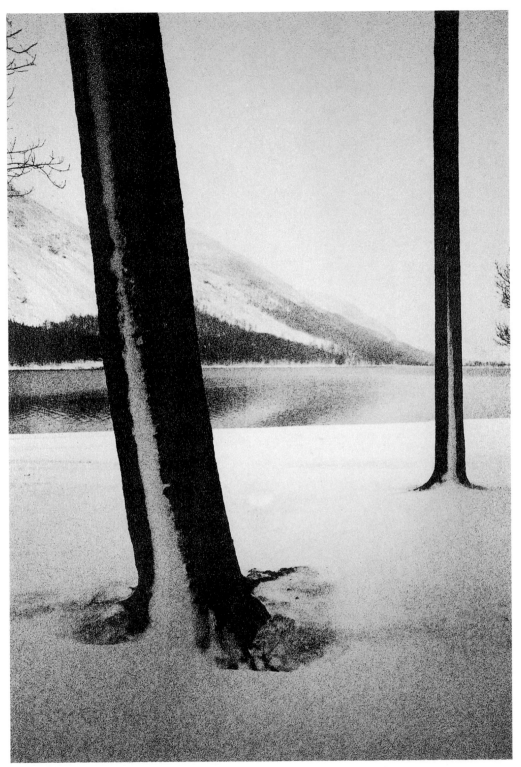

Jo Crowther

Print: Buttermere in winter, Lake District

Sometimes adverse conditions provide wonderful images. I took this photograph at dusk in Buttermere Valley and there was deep snow on the ground and virtually no light when I took a late walk to the Lake's edge and found these beautiful trees striped with snow. Somehow the lack of light and freezing temperature seemed to suspend the scene. I took just one frame, knee-deep in snow, hands trembling with the cold.

Technical Details
35mm SLR camera with a 24mm lens. Exposure was 1/15 second at f5.6. Film stock was Ilford XP2, developed in C-41 chemistry. I used a 25A red filter to increase contrast back to a normal level, but also to reduce shadow detail. A lovely thin negative was produced, perfect for lith printing.

Print Details
I flashed Kentmere Art Classic paper then overexposed the image by 2 stops, giving 60 seconds at f4. Enlarger type was a cold cathode.

Effect Details
The print was developed in Novolith for approximately 6–7 minutes. A little selective bleaching with a cotton bud was all that was needed to produce the print I was aiming for. The stippled finish of the Art Classic paper and gritty lith developer produced an interesting effect.

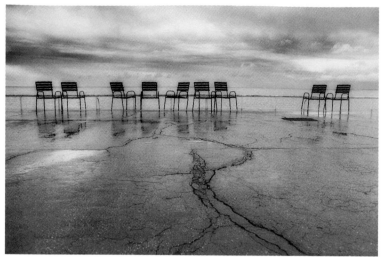

Print without effects

Jo Crowther

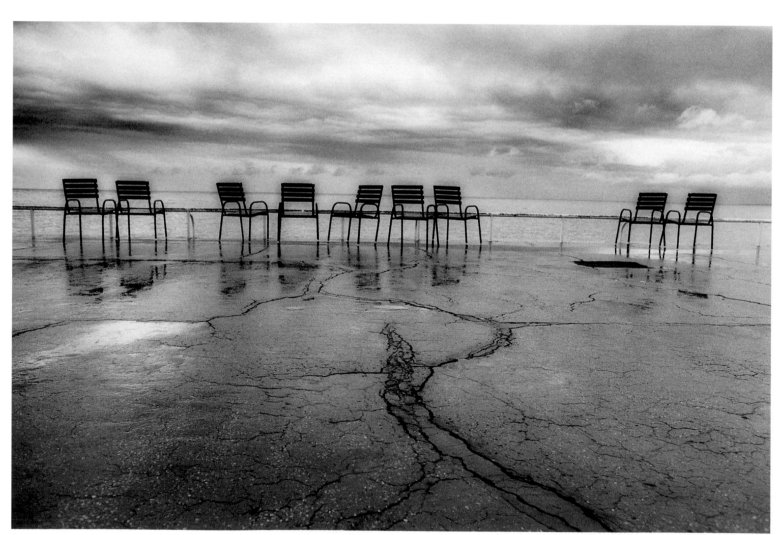

Print: Chairs, Nice, South of France

It was a moody, overcast morning on the Promenade des Anglais. It had just stopped raining and the light seemed irides-cent, and the actual colours in the scene were virtually the same as they appear here in this toned black-and-white image. I realised that there was a shot somewhere between the elements of sky, chairs and wet reflections and shot two frames immediately. Lowering the horizon gave drama to the otherwise fairly plain foreground. It is highly satisfying to see a scene transformed from the mundane to the memorable when touched by the appropriate light.

Technical Details
35mm SLR camera with a 24mm lens and a 25A red filter to raise the contrast. Exposure was 1/30 second at f8.5. Film stock was Fuji Neopan 400, developed in ID 11 for 7 minutes.

Print Details
It is useful to play around with the contrast at both the negative and print stage as it can produce some interesting results. I used Ilford Multigrade IV paper with filtration set at grade 3. The entire image was given an exposure of 28 seconds at f5.6, with an additional 14 seconds exposure at the top and bottom of the print at grade 3 1/2. I developed the print in PQ devel-oper for 2 minutes. The exposure was made using a cold cathode enlarger.

Effect Details
The paper was post flashed to flatten off the highlights, and I used a softer filter under the enlarger lens to create a diffused look. I then toned the print in an iron-blue toner until I was happy with the result. I also did some selective bleaching to add zing to a few highlights – in the sky and puddles by the chairs.

Print without effects

Tip: Bleach applied directly and selectively is often more valuable than dodging, as it will raise the highlights without degrading the shadow areas.

Print: Trucks, Rapid City, South Dakota, USA

It had been snowing on and off all day, and by late afternoon the build-up of fresh snow over melted snow made everything look exquisitely beautiful in these freezing conditions. I took this photograph from a hotel window, having to lean right out to lose the edge of the building. A slightly longer lens than I would normally use has given a strong 'stacked-up', graphic look. The light falling on this contrasty scene was fortunately lovely and soft.

Technical Details
35mm SLR camera with a 35–105mm zoom lens. Exposure was 1/30 second at f11. Film was Fuji Neopan 400, developed in ID 11 for 7 minutes at 20 degrees C.

Print Details
Ilford Multigrade IV paper with a matt finish, developed in PQ developer for 2 minutes. I set a filtration of grade 3, giving a basic exposure of 18 seconds at f5.6 using a cold cathode enlarger. The exposure was made through a softer filter placed under the lens. An additional exposure of 9 seconds was given to the outer shadows to give more 'weight' to this area, while care was taken to shade the trucks during the exposure.

Effect Details
In addition to using a diffusion filter I toned the print in an iron-blue toner. Using the toner gives a half grade increase in print contrast – I allowed for this during the exposure by using a contrast filter a half grade softer than I would normally have used. I also gently bleached areas of the car bonnets to increase the contrast and the impact of the snow.

Jo Crowther

Tip: I normally have company in the darkroom. This helps to prevent long spells from becoming tedious and also gives an extra dimension as I have a second pair of experienced eyes to help bring the print to completion. John Ray Bettell and I work together on my prints, and in this way time in the darkroom is very much a creative process.

Print without effects

Print: Pyramids, Giza, Egypt

I was so stunned upon seeing the pyramids for real after knowing them through other people's images that I couldn't even consider taking a photograph for three days. The sheer scale of the site and beauty of the vastness took my breath away. It was through not taking pictures and just looking at the scene that I saw this image emerge. Lying on my belly with my chin in the sand I could lose the area of middle ground, while emphasising the relationship between the foreground and the pyramids by using a wide lens. Everything else was serendipitous – the sky was lined up with strands of cirrus that mirrored the tyre tracks and the scene was softly lit from the back-left of the shot.

Technical Details
35mm SLR camera with a 24mm lens. Exposure was 1/60 second at f11. I incorrectly processed the Ilford Delta 100 film I was using so that it was effectively one stop underexposed, resulting in a very thin negative.

Print Details
Agfa MCC 118 semi-matt paper. I used a filtration factor of grade 5 and an exposure of 10 seconds at f8. I developed the print in Multigrade developer, 1 to 9, for 2 minutes. A cold cathode enlarger was used for this print.

Effect Details
The problem here was a very thin negative that lacked contrast and detail. The solution, apart from printing as hard as possible, was to selenium-tone the print to raise contrast and to salvage some detail out of very little. The selenium tone helped to build up the shadow areas and I finally achieved a very acceptable print – against the odds!

Jo Crowther

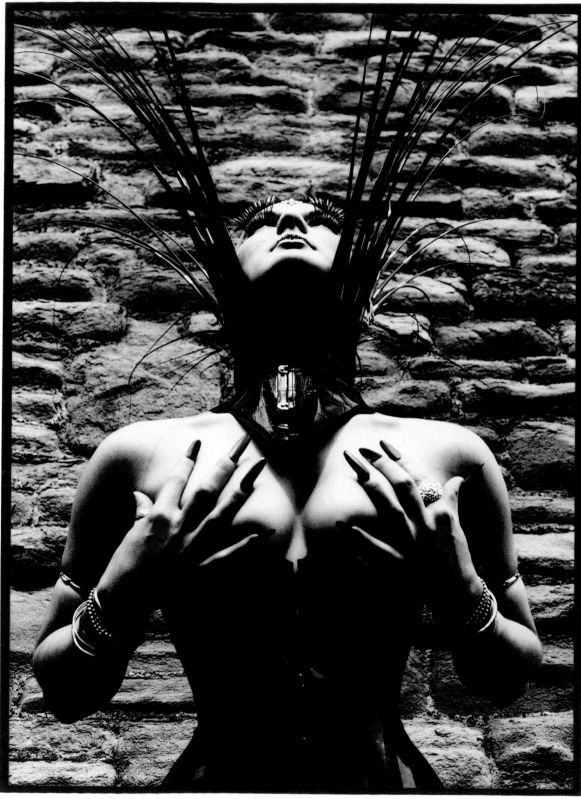

Emma Delves Broughton

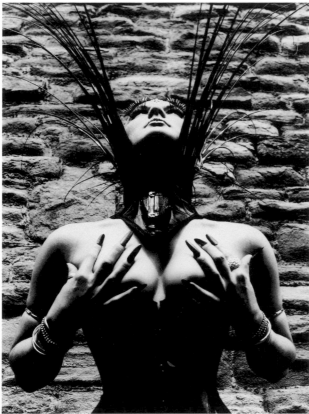

Print without effects

+9 secs

-6 secs

-6 secs

overall 19 secs

Print: Kate 1998

I wanted to highlight the strong shapes of this collar by designers Beehive & Love and felt that I needed a bald head to highlight it to its full potential. Luckily for me, the model I was using, Kate, had exactly this style. This image was shot on location in Bristol on some stone steps, and I decided to make use of the strong overhead lighting to separate Kate from the wall. I did the styling and make-up myself.

Technical Details
6 x 7cm SLR camera with a 90mm lens. Exposure 1/60 second at f5.6. Kodak T-max 100 developed in Kodak T-max RS for 6 1/2 minutes at 24 degrees C.

Print Details
This print was exposed for 19 seconds in total at f8 using a grade 3 contrast filter. I held back the wall in the area around the collar for about 6 seconds while the left-hand edge and top of the print have been burned in by 9 seconds. The black border was added using a cardboard mask for a 12 second exposure. Paper choice was Agfa Multicontrast Classic, developed in Agfa Neutol WA for 2 minutes. The enlarger was a condenser type.

Effect Details
I toned the print in Rayco sepia toner for approximately 2 minutes and followed this by using Tetenal gold toner for 4 1/2–5 minutes.

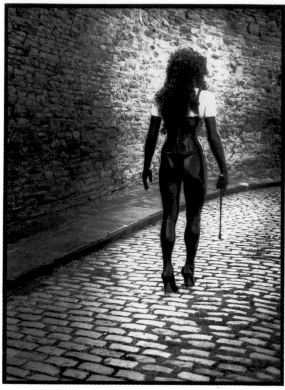

Print without effects

Print: Katrina 1998

This was shot on location in Bristol early one morning on a sunny day. As the direct sunlight was too distracting, I moved the model into the shade to reduce the contrast while the softer light allowed the tonal range to be retained. This also helped to keep Katrina cool in her remarkable rubber outfit, which had a good shine to it thanks to the time we spent preparing it for the shoot.

Technical Details
6 x 7cm SLR camera with a 180mm lens. Exposure was 1/125 second at f8. Kodak T-max 100 developed in Kodak T-max RS for 6 minutes at 24 degrees C.

Print Details
This print on Agfa Multicontrast Classic was exposed for half the time through ordinary tracing paper and for the rest of the time without it. Total exposure was for 9 seconds at f8 using a filtration of grade 2.5. The outfit was then held back while the surrounding area was burnt in by about 28 seconds. The black border was added using a cardboard mask for a 12 second exposure. The print was developed in Agfa Neutol WA for 2 minutes, again using a condenser enlarger.

Effect Details
In addition to using tracing paper during the exposure, the print was toned using the blue toner (parts A and C) from the Colorvir kit, left in the solution until the effect I wanted was achieved.

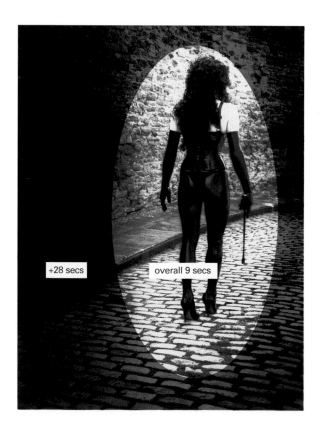

+28 secs overall 9 secs

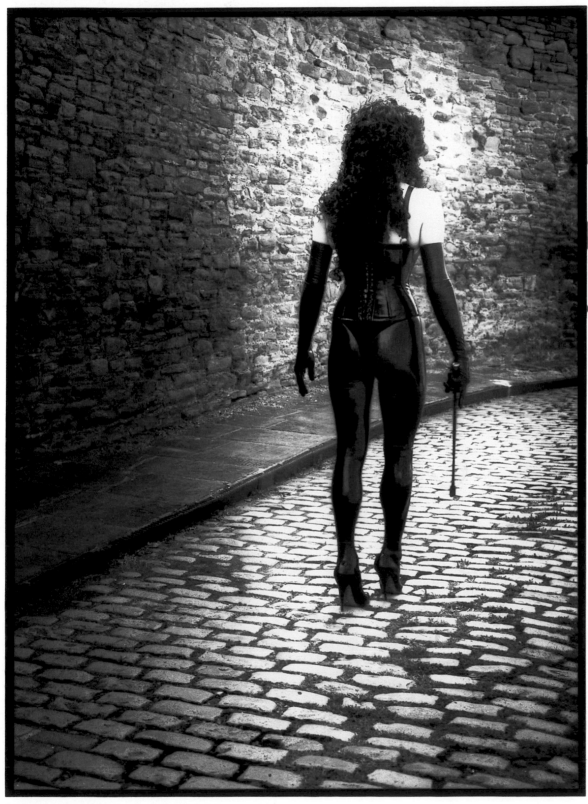

Emma Delves Broughton

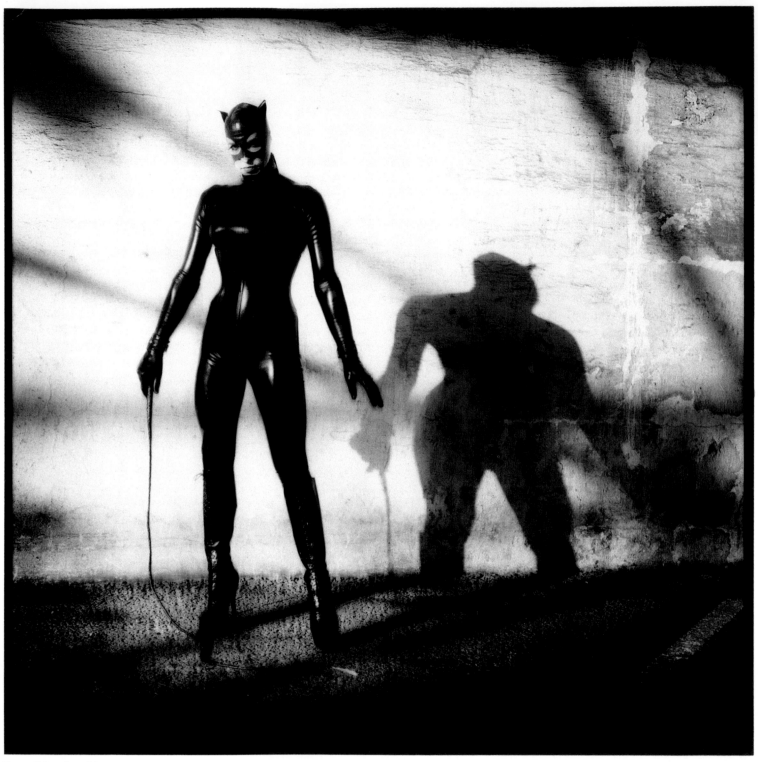

Emma Delves Broughton

Tip: When using strong solutions of selenium toner be sure to use a well-ventilated darkroom to prevent fumes from building up. Selenium fumes can be very strong and unpleasant. It is also toxic, so take sensible precautions.

Print: Katwoman

I waited about six months for the model to get all the elements of the outfit together for this look. Everything was to be in rubber – the corset, catsuit, gloves and hood, which was made to specific design. I shot the picture late in October on location in Bristol in a disused car park. I set up the equipment and the sun came out just at the right moment to create strong shadows and exactly the kind of atmosphere I was looking for.

Technical Details
6 x 6cm twin lens reflex camera with an 80mm lens. Exposure was 1/125 second at f8. Kodak T-max 100 uprated to ISO 400 and developed in Kodak T-max RS for 11 minutes at 24 degrees C.

Print Details
This print was exposed for 8 seconds through ordinary tracing paper and then for 8 seconds without it at f16. I used a filtration of grade 3 on my condenser enlarger. The edges were burnt in by about 30 seconds at grade 2 and the black border was added using a cardboard mask for a 12 second exposure. I used Agfa Multicontrast Classic paper developed in Neutol WA for 2 minutes.

Effect Details
The print was toned in Kodak selenium toner, diluted 1 to 4; the strong selenium solution helped to create the overall effect by intensifying the image.

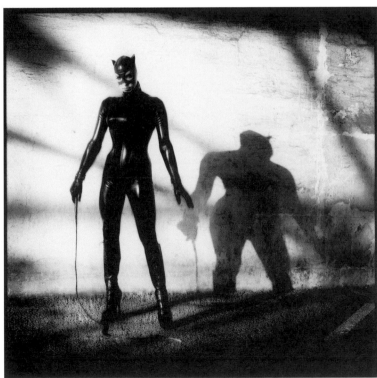

Print without effects

overall 16 secs +30 secs

Print: Emily 1998

Shot at around 3 a.m., this model was only too happy to recline and have a quick nap under the warmth of about 3KW of tungsten lighting! This was the last outfit for the night's shoot and I chose our white fluffy rug as the background to contrast with the shiny PVC of the outfit. I felt the composition needed a simple yet strong shape because the model was reclining.

Technical Details
6 x 7cm SLR camera with a 90mm lens. Exposure 1/125 second at f8. Kodak T-max 100 uprated to 400 developed in Kodak T-max RS for 11 minutes at 24 degrees C.

Print Details
This print was exposed for 6 seconds through ordinary tracing paper and for 6 seconds without it at f8 using a filtration of grade 5. I also used a card vignette to hold back the background for 6 seconds. The black border was added using a cardboard mask for a 12 second exposure. I used my favourite paper and developer combination of Agfa Multicontrast Classic with Neutol WA developer. Enlarger choice was a condenser.

Effect Details
Using the tracing paper during part of the exposure created a subtle, diffused look, whilst the final touch was to tone the print first in Rayco sepia toner and then in Tetenal gold toner.

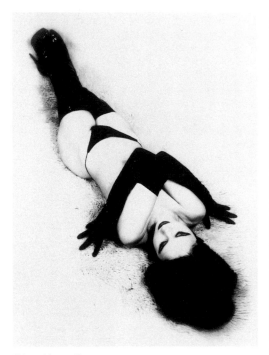

Print without effects

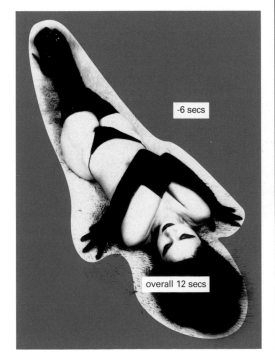

-6 secs

overall 12 secs

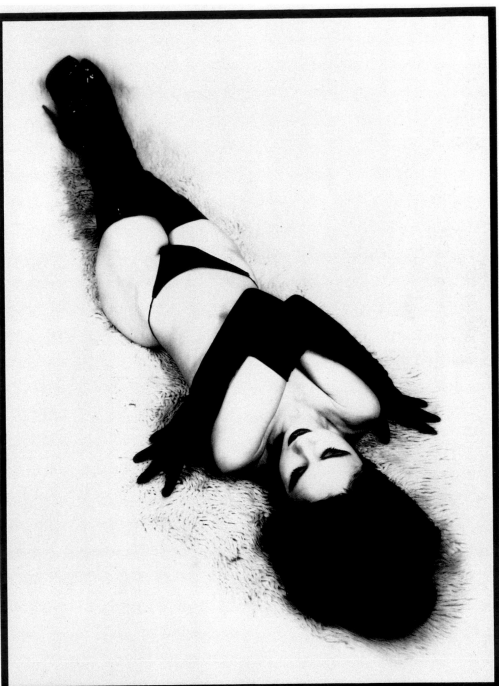

Emma Delves Broughton

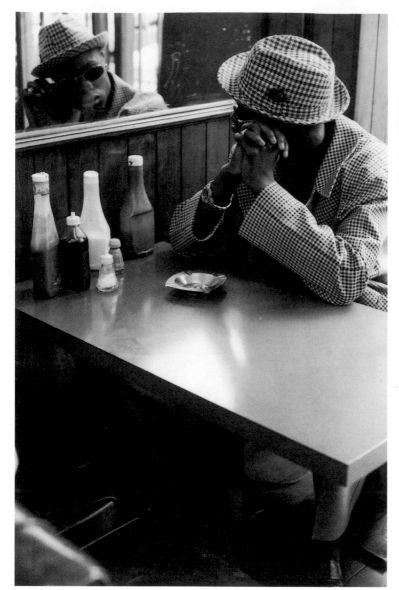

Print without effects

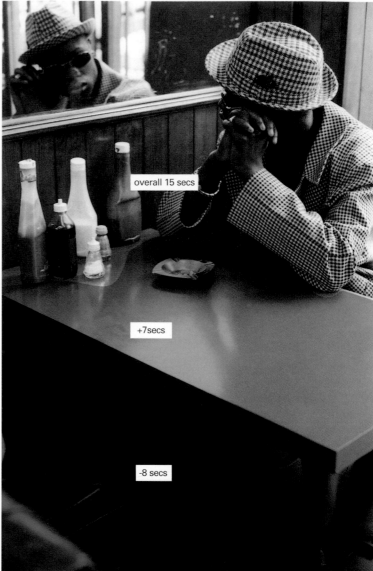

overall 15 secs

+7secs

-8 secs

Tip: With many modern sepia toners you can adjust the dilution to create an effect ranging from near-yellow to a deep brown. If you are unsure which effect you want, start with the more dilute option, gradually strengthening the solution until you achieve the colour you want.

Michael Miller

Print: Time to reflect

For this photograph, as for the others that follow, my aim was to blend the classic look of the 1970s with the cultural expression of the Afro Caribbean people. I wanted my pictures to be modern fine art classics. In this shot the café setting could have come from any era, and turning the labels of the bottles away from the viewer ensured that they didn't give the game away.

Technical Details

35mm SLR camera with a 50mm lens. Exposure was 1/60 second at f8. Ilford XP2 developed in Ilford XP2 developer.

Print Details

Ilford Multigrade IV pearl paper developed in Multigrade developer at a dilution of 1 to 9 for 60 seconds. As this print contained lots of shadow as well as highlights it was necessary to do some burning in and dodging. The table was exposed for an extra 7 seconds while the area under it was held back for 8 seconds. The basic exposure was 15 seconds at f8, using a condenser enlarger.

Effect Details

The prints here are all toned with a sepia toner. My aim was to add warmth and mood but to keep the effect very subtle. By careful use of the sepia I kept the original atmosphere of the picture and the emphasis on a classic image. Sepia was the perfect choice for this as it is a toner that goes beyond any trends within the fashion industry, making the pictures harder to pin a date on. I used Paterson acutone sepia toner for this, giving approximately 5 minutes in the bleach and 4 in the toner itself.

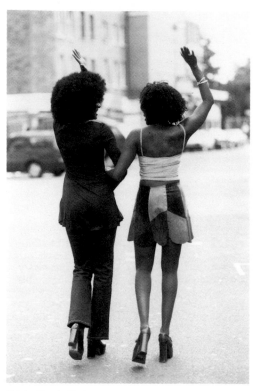

Print without effects

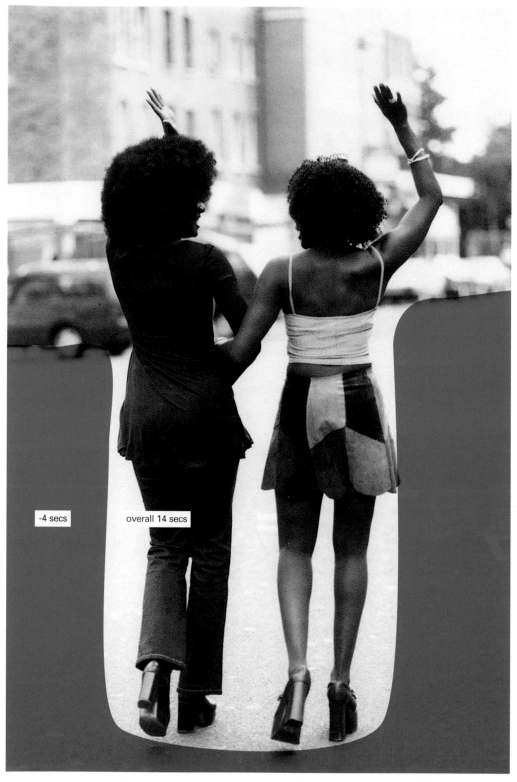

-4 secs

overall 14 secs

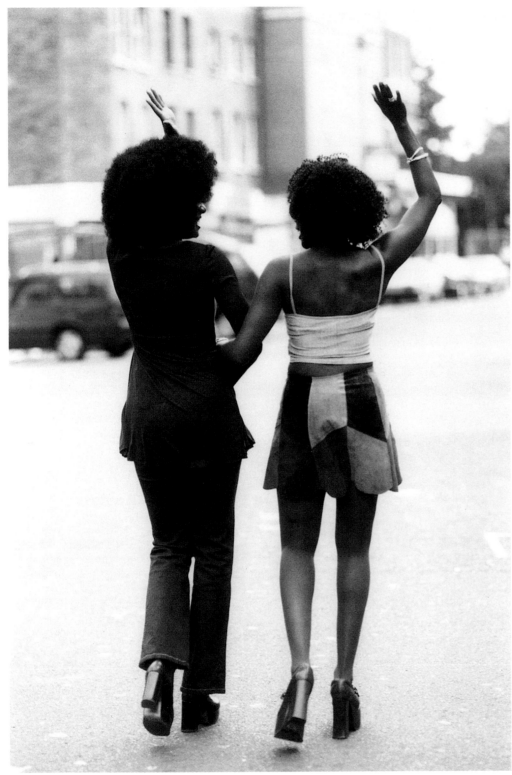

Michael Miller

Print: Mirrored souls

This image, like the others here, was influenced by movies, fashion and music. Shooting the ladies from behind gives the image an arresting quality because it stands out from the standard face-on portraits. It also adds a natural air – the photographer could be any man who has just seen two pretty ladies stroll by.

Technical Details
35mm SLR camera with an 80–200mm zoom lens. Exposure was 1/500 second at f8. Kodak T-max 400 developed in T-max RS developer for 8 minutes.

Print Details
Ilford Multigrade IV pearl paper developed in Multigrade developer diluted at 1 to 9. Development time was 60 seconds. I paid a lot of attention to achieving the right tonal contrast between the blacks and greys in the shadows. I chose grade 3 for this print with an exposure of 14 seconds at f8. The area around the girls was shaded for 4 seconds to 'knock back' unwanted detail in the pavement. I used my condenser enlarger for this print.

Effect Details
Again this print was toned in sepia, this time giving around 4 minutes in the bleach and 3 minutes in the toner. This gave a slightly cooler image colour than the previous print, which I felt was a better representation of the quality of light when the shot was taken.

Tip: When using a sepia toner with resin-coated paper be prepared to give the print longer in the bleach bath than a fibre paper. With this material the process happens more slowly and extra patience is needed.

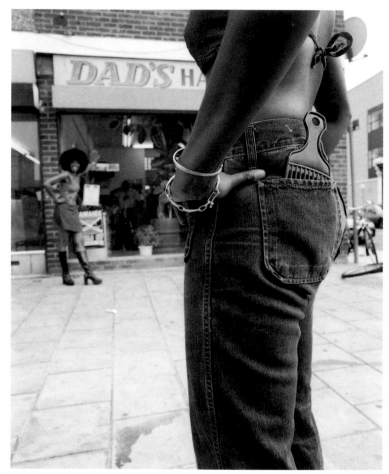

Print without effects

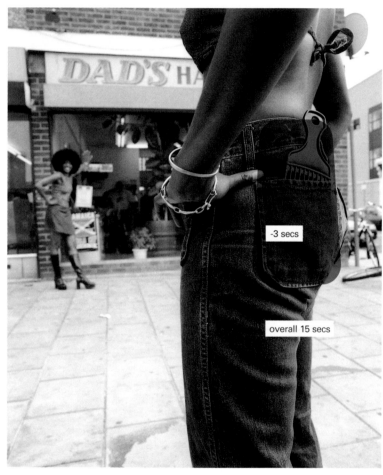

-3 secs

overall 15 secs

Print: Head to head

I wanted to combine sexuality, style and natural harmony in this shot and to add a certain sense of fun. I chose this viewpoint that shows the hair-dresser's comb in the model's pocket like a pistol ready for firing, while her hands are on her hips as if prepared for a quick draw. The other lady swaggers and leans against the shop window like a cocksure gunfighter, though her sunny expression shows that this is all a game. Cropping the near lady off above her bust adds sensual mystery.

Technical Details
6 x 7cm medium-format camera with a 90mm lens. Exposure was 1/125 second at f8. Ilford XP2 rated at 400 developed in XP2 developer.

Print Details
Ilford Multigrade IV paper developed in Multigrade developer diluted at 1 to 9. As I wanted to enhance sharp detail yet maintain contrast, the paper was used at grade 4 with an overall exposure of 15 seconds at f8, with a condenser enlarger. I gave a brief shading of 3 seconds or so on the comb itself and back pocket to provide a little extra highlight.

Effect Details
This print was given exactly the same time in the bleach and sepia as the previous print – 4 minutes and 3 minutes respectively. The reason for this was to keep continuity in the outdoor shots.

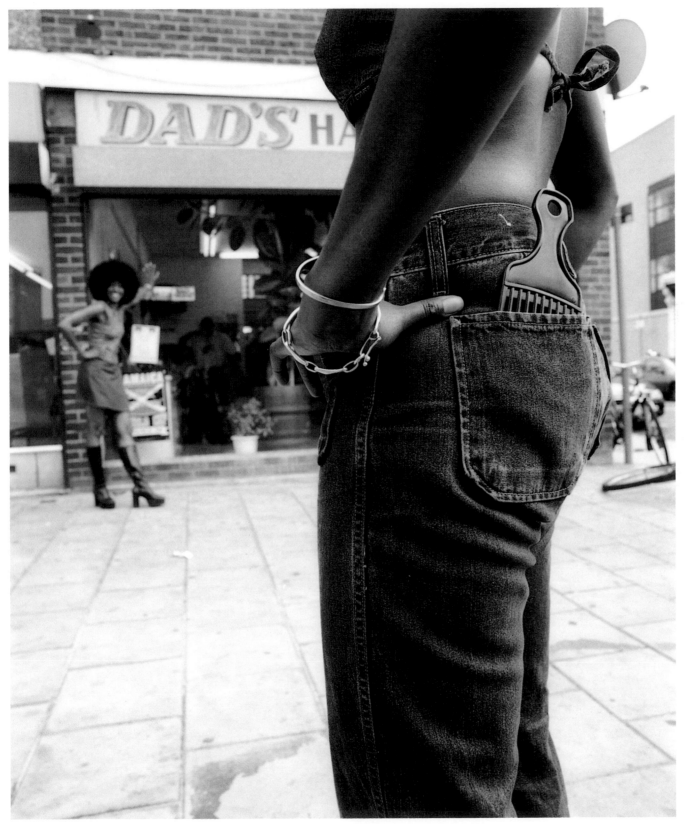

Michael Miller

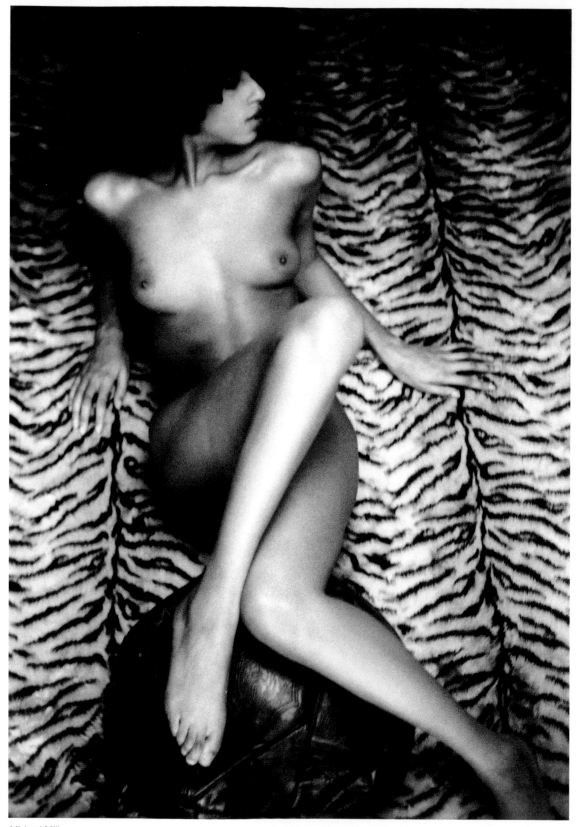

Michael Miller

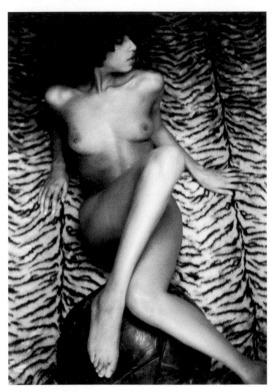

Print without effects

Print: Dark nature

The fabulous animal skin here gives this image lots of '70s chic and I asked the model to place her hands on it like a tiger ready to strike. Just like a cat she looks away from us but we know she is aware of our every move.

Technical Details
35mm SLR camera with a 50mm lens. Exposure was 1/60 second at f1.4 with a studio tungsten light. Agfapan 400 developed in Ilford ID 11 for 8 1/2 minutes.

Print Details
Ilford Multigrade IV gloss paper developed in Multigrade developer diluted at 1 to 9. The overall exposure was 12 seconds at f8, giving 4 seconds shading to the area in the top right-hand corner. This kept the pattern of the tiger skin from disappearing into the background too soon. I used an enlarger with a condenser light source.

Effect Details
The combination of rating the paper at grade 2 and of setting a wide aperture helped reduce contrast and gave this picture an overall soft tone. To enhance this image further Paterson acutone sepia toner was used. I bleached the print for five minutes followed by five minutes in the sepia toner.

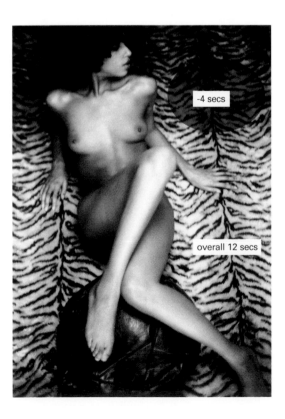

-4 secs

overall 12 secs

Glossary

Acutance: Apparent sharpness of the negative or print. The use of an acutance developer will enhance contrast around edges, giving an appearance of high definition.

Aperture: Variable-sized hole used to control the intensity of light passing through a lens on to the film or paper. Camera lenses are calibrated using f numbers such as f2.8, f4 and f5.6, each reducing the image brightness by 50%. Enlarging lenses can be simply marked numerically i.e. 1, 2, 4 and so on, in steps of 50% brightness reduction.

Archival: To process and store negatives and prints in such a way as to maximise lifespan almost indefinitely.

Bleaching: The reduction in density of an exposed and processed print by application of a dilute solution of Potassium Ferricyanide. It can also be used to remove black spots and is often used as a prelude to toning.

Bromide Paper: A printing paper that gives a blue-black image when the appropriate developer is used.

Burning in: A printing technique in which additional exposure is given to selected parts of the image to create a darker tone.

C-41 Chemistry: The standard colour negative chemistry which is also used to develop black-and-white chromogenic film.

Chloro-bromide Paper: A printing paper that gives a warm, brown-black image when used with the appropriate developer.

Chromogenic Film: Film, such as Ilford XP2 Super, which uses dyes to create a monochrome image instead of the silver-based emulsion used in conventional black-and-white films.

Contact Print: A print made by placing a negative directly on to the printing paper, held flat by glass during exposure to produce a same-size image. This is the normal way of making reference prints from a complete roll of film.

Contrast: The difference in brightness between the lightest and darkest areas of a scene or the lightest and darkest tones of a negative or print.

Definition: The ability of a lens or a film to record fine detail in sharp focus.

Depth of Field: The distance in front and behind the point at which a lens is focused which will be rendered acceptably sharp. It increases when the aperture is made smaller and extends about two-thirds behind the point of focus and one-third in front. The depth of field becomes smaller when the lens is focused at close distances. A scale indicating depth of field for each aperture is marked on most lens mounts and it can also be judged visually on SLR cameras which have a depth of field preview button.

Depth of Focus: The term used to describe the range of sharp focus at the film plane and which increases when the aperture is reduced. Setting a small aperture on the enlarging lens will help to ensure the image will be in sharp focus when the negative is not completely flat in the carrier or focusing is not 100% accurate.

Diffusion (enlarger): Enlarger that passes a diffused light through the negative giving a lower-contrast image than others, with a tendency to minimise negative imperfections.

Diffusion (image): A means of softening the image by the use of a special filter or suitable piece of material.

Dodging: A printing technique in which a selected area of the image is shielded during the exposure to make it lighter in tone.

Emulsion: The light-sensitive coating on a film or paper which forms the image after exposure and development.

Farmer's Reducer: A chemical solution that bleaches away the silver image. It can be used to brighten small areas of a print or the whole print can be immersed in the solution to rescue a muddy or overexposed image. After the reducer has been used, the whole print must be fixed again and washed.

Fibre-based Paper: Printing paper in which the emulsion is coated on to paper made from natural wood fibre. It requires thorough fixing and washing to prevent image deterioration but produces a superior result to resin-coated paper. It's available in a variety of weights and surface textures.

Flashing: The technique of giving a piece of printing paper a very brief exposure to ambient light before exposing the negative in order to reduce the image contrast.

Focus Finder: A high-powered, microscope-style magnifier that is used on the enlarger baseboard allowing a negative to be focused with great accuracy on the film grain, even when the enlarging lens is stopped down.

Fogging: The effect of exposing film or paper to unsafe ambient light, often caused by a light leak in a darkroom or a safelight which is too bright or has the wrong screen.

Grain: The structure of a film's emulsion which can become visible at high degrees of enlargement. It is more prominent with fast films and can be used for creative effect.

High Key: A term used to describe a print or image which is dominated by light tones.

Hypo Eliminator: A solution which can be used to reduce the amount of time a film or fibre-based print needs to be washed for archival permanence.